MALMSTROM
AIR FORCE BASE
THROUGH TIME

JOSEPH T. PAGE II

AMERICA
THROUGH TIME®
ADDING COLOR TO AMERICAN HISTORY

This book is dedicated to the warrior women in my life,
for showing me the wholeness of the human experience.

America Through Time is an imprint of Fonthill Media LLC
www.through-time.com
office@through-time.com

Published by Arcadia Publishing by arrangement with Fonthill Media LLC
For all general information, please contact Arcadia Publishing:
Telephone: 843-853-2070
Fax: 843-853-0044
E-mail: sales@arcadiapublishing.com
For customer service and orders:
Toll-Free 1-888-313-2665

www.arcadiapublishing.com

First published 2021

ISBN 978-1-68473-010-0

Typeset in Mrs Eaves XL Serif Narrow
Printed and bound in England

CONTENTS

ACKNOWLEDGMENTS

Foremost, I would like to thank my parents, Joseph and Kathleen. Exposure to military life as a child influenced my decision to join the Air Force's "Order of Subterranean Sentinels."

Dave Fields was instrumental in getting me passionate about Malmstrom's history. His website—MinutemanMissile.com—included a large reference library about Minuteman's history and its place in Montana. His email exchanges gave me some bits of local color about the base and how the community perceives the missiles in their backyards.

I would like to recognize Lt.-Col. Douglas Carmean (341MW/IG) with a hearty "thanks!" I met Doug as a second lieutenant up in Minot and knew immediately that this "kid" was going places. The nation is a safer place with people like Doug in the leadership ranks.

I would also like to acknowledge many unnamed Malmstrom missileers for the stories of their time in the Northern Tier. My experience in North Dakota gave me the common vernacular needed to talk missiles, but their stories revealed a welcoming community in Great Falls, a supportive base environment, and dedicated men and women preserving the effectiveness of the Minuteman weapon system on a daily basis.

Thank you to Mr. Rob Turnbow, the Malmstrom Air and Space Museum director. I am sure he either gritted his teeth or rolled his eyes when he received that first introductory email from me. His professionalism is unmatched, and Rob's passion for Malmstrom's history shines through in his interviews and articles.

Finally, I would like to thank my wife and children for their patience with my writing endeavors.

INTRODUCTION

CREATION OF GREAT FALLS ARMY AIR BASE

Malmstrom Air Force Base traces its modest beginnings to the outbreak of World War II. In 1939, two Montana senators—Burton K. Wheeler and James E. Murray—contacted the War Department and requested they consider the development of a military installation in Great Falls. Construction began on Great Falls Army Air Base (GFAAB) on May 9, 1942. The base was informally known as East Base since the 7th Ferrying Group was stationed at the municipal airport located on Gore Hill. The air base's mission was to serve as a training and logistics hub for training bomber aircrews. The base received its first B-17 Flying Fortress on November 30, 1942.

In preparation for large-scale bombardment missions in the European Theater of Operations, these Montana-based aircraft would take off at predetermined times, form up in organization echelons over their respective location, and join into a group formation in the central Montana skies. Organizational skills with maneuvering aircraft in large numbers proved to be critical during the decisive raids over Germany during the Eighth Air Force's daylight precision bombing campaign. Training B-17 crews occurred until late 1943, when aircrews and aircraft left for Europe.

LEND-LEASE PROGRAM

In October 1943, the Army Air Forces selected GFAAB as the start of an air route to Russia, supporting the Lend-Lease program. The Soviets were applying military pressure on the Eastern Front, though lacking quality military equipment. The U.S. offered several types of military planes to the Soviet Army, including the P-39 Airacobra, C-47 Skytrain, B-25 Mitchell, and A-20 Havoc. Both women and men flew aircraft to GFAAB. As part of the Women Airforce Service Pilots (WASPs), women flew several aircraft through Great Falls during the war. Other aircraft arrived by rail and were assembled on-site. Once readied,

these aircraft flew from Montana along the Alaskan–Siberian route through Canada, straight to Ladd Field in Fairbanks, Alaska. From this embarkation point, Soviet pilots would take the aircraft to Russia, for use against Germany in defense of the Soviet Union.

SEPARATE SERVICE

After the end of World War II, the Army Air Forces assigned GFAAB an administrative role, continuing to serve as an aerial port for cargo and personnel movement to Alaska. On September 18, 1947, the Department of Defense and the United States Air Force was created with the signing of the National Security Act. With the creation of the Air Force, most military installations supporting the new service were renamed air force bases (AFBs) from army airfields or army air bases. Subsequently, the Air Force renamed GFAAB to Great Falls Air Force Base on January 13, 1948.

OPERATION VITTLES

The second defining event in the early years of the air base was the Berlin Blockade and corresponding airlift of supplies into the beleaguered German city. After the end of World War II, the U.S., British, French, and Soviet military forces divided Germany into occupation zones. Similarly, divided occupation zones even split the city of Berlin. The United States, Britain, and France controlled the western part of Berlin while Soviet troops controlled the eastern portion. The previous wartime alliance between the Western Allies and the Soviet Union ceased, with the Soviets attempting to seize the western occupation zones through a blockade of rail, water, and road access to West Berlin. The blockade began on June 24, 1948, with the U.S. and Britain airlifting food and fuel to Berlin via Allied airbases in western Germany during Operation Vittles.

Aircrews aboard transport planes approaching Berlin had to obey strict air traffic control and timing procedures to land and offload during an extremely short time (just forty-nine minutes). Just as the base trained bomber crews during the war, America called upon Great Falls to train cargo aircrews with the exacting procedures required over Berlin. On August 13, 1948, the Military Air Transport Service's 517th Air Transport Wing (later redesignated as the 1701st Air Transport Wing) assumed responsibility for training C-54 Skymaster crews. The weather in Great Falls was similar to Berlin, so radio beacons created flight corridors similar to ones in Germany, aligned to add realism during training flights. Aircrews accomplished a twenty-one-day course with 133 hours of instruction to synchronize replacement crews with clockwork precision required during the Berlin Airlift.

The Allies, with the Great Falls-trained aircrews, flew approximately 2.3 million tons of cargo into Berlin during the course of the airlift. Realizing their gambit had failed, the Soviets limited the blockade on May 12, 1949, although Allied aircrews continued flying precious cargo into the city through September 30, 1949. However, the operation was not without its losses. Seventeen American aircraft crashed during Operation Vittles, recording thirty-one American airmen casualties.

COLD WAR AIR DEFENSE

While the American military was undertaking operations during the Korean War in mid-1950, Great Falls AFB became a vanguard in the North American Air Defense (NORAD) mission. On March 1, 1951, the 29th Air Division (29 AD) activated at the base, with various organizations including fighter-interceptor squadrons, an aircraft control and warning squadron, and ground observer attachments around the 29 AD's area of control. In 1953, the air division saw the activation of its own flying unit at Great Falls AFB, the 29th Air Fighter Interceptor Squadron.

The next year, a shift in organizations brought the 407th Strategic Fighter Wing to Great Falls and placed the base under the control of Strategic Air Command. The unit's mission was to provide protection for strategic bombers heading on an attack vector over the North Pole. The KB-29s, and later KC-97s, provided air refueling for both strategic bombers and the assigned fighters. In the mid-1950s, SAC eliminated requirements for strategic fighters, forcing the 407 SFW to inactivate in 1957. The 407 ARS, however, remained active until 1961 with its KC-97 tankers.

A year later, on October 1, 1955, GFAFB was officially renamed Malmstrom Air Force Base in honor of Col. Einar A. Malmstrom, who died on an administrative mission in a T-33 training aircraft. In 1957, the 407th SFW was deactivated and replaced by the 4061st Air Refueling Wing (ARW), flying until 1961; Malmstrom AFB would not see a return to aerial refueling until almost three decades later.

The air force base continued to support NORAD through the operations of the 24 Air Division. The construction of a semi-automatic ground environment (SAGE) blockhouse allowed connectivity to radar early warning stations around the air defense sector. The location in sparsely populated Montana was desirable for NORAD's alternate command post, in case of destruction of the primary command post inside Cheyenne Mountain (Colorado).

On December 23, 1959, the service's Ballistic Missile Committee selected Malmstrom as the first of six locations for the newest ICBM, the Minuteman. Montana's low population, expansive lands and road network, and distance to the Soviet Union indicated favorable factors for Minuteman basing. Within the Minuteman missile enterprise, Malmstrom would be known as Wing One.

341ST STRATEGIC MISSILE WING

Malmstrom AFB's host organization had a storied history, beginning in the China-Burma-India (CBI) Theater of World War II in 1943. As one of the first bomber units in the CBI, the 341st Bombardment Group (Medium) flew B-25 Mitchell bombers against Japanese transportation routes in central Burma, destroying targets such as bridges and railway yards to delay supply movement for Japanese troops.

STRATOJET FLYERS

The 341st gained new life in March 1953 as the 341st Bombardment Wing, Medium at Abilene AFB (later renamed Dyess AFB), Texas. The wing flew B-47 Stratojet bombers, supported by KC-97 Stratotankers for strategic bombardment with aerial refueling support. The wing's days of flying strategic bombers ended in mid-1961, when the 341st Bombardment Wing, Medium was inactivated on June 25, 1961. This pause was short-lived, since the wing was reborn as the 341st Strategic Missile Wing (341 SMW), three weeks later on July 15, 1961, at Malmstrom AFB, to house the SM-80 (later LGM-30) Minuteman intercontinental ballistic missile (ICBM).

MINUTEMAN IN THE HEARTLAND

The development of the Minuteman system was a revolutionary step beyond previous ICBMs. First-generation ICBMs (Atlas and Titan) required on-site maintenance and operations crews to fuel and launch the missiles within a fifteen-minute timeframe. Missiles sat empty of fuel until required to launch, delaying critical response time. Minuteman was a solid-fuel, minimally maintained system that sat in unoccupied remote launch facilities (LFs) until needed. Operations crews inside remote launch control centers (LCCs) could monitor ten missiles. Underground housing of Minuteman missiles kept the missiles out of the public eye and safe from any pre-emptive or retaliatory strikes from the enemy. The responsiveness echoed in its name since the entire timeline from launch to arrival on target took a fraction of the time of the Atlas and Titan fueling process alone.

The primary unit of a Minuteman wing is a strategic missile squadron (SMS), whose purpose is to conduct strategic warfare in support of an emergency war order, an executive command to initiate launch procedures. The initial activation of the 341 SMW as a Minuteman wing included three strategic missile squadrons (SMS): 10th Strategic Missile Squadron (10 SMS); 12th Strategic Missile Squadron (12 SMS); and 490th Strategic Missile Squadron (490 SMS).

The Air Force purchased approximately 5,200 acres of land from local landowners and from Montana for missile alert facilities (MAF) and LF sites. Each MAF and LF required approximately 2 to 6 acres plus access roads and utility lines. The Boeing-designed LCC command and control system continually monitored the operational status and security of its LFs via an underground cable system, called the hardened intersite cable system (HICS). This pressurized copper cable network connected the five LCC/LF installations within a squadron, enabling the monitoring and control of all fifty of the squadron's missiles from any facility.

ACE IN THE HOLE

The first LGM-30A Minuteman I arrived at Malmstrom on July 23, 1962, and after emplacement, LF Alpha-09 inside the 10 SMS squadron area became the first Minuteman missile site in the United States. On October 26, 1962, at 11.16 a.m., the Alpha-06 went

on strategic alert in response to the placement of nuclear missiles in Cuba by the Soviet Union. During this crisis, Malmstrom maintenance teams placed five Minuteman missiles on strategic alert. By July 3, 1963, the 10 SMS, 12 SMS, and 490 SMS reached full operating capability, with 150 Minuteman I ICBMs emplaced.

DEUCE

The 564th SMS, activated in 1965 became the fourth squadron for the wing and the twentieth (and final) Minuteman squadron activated. A unit storied in missile history, the 564th was the first Atlas ICBM squadron on alert, as part of the first ICBM wing in the Air Force. After the phase-out of the Atlas ICBM, the 564th was inactivated in 1964. The Air Force re-activated 564th in 1965 to operate the WS-133B system with the new LGM-30F Minuteman II. The GTE/Sylvania-developed command and control system offered distinct differences in technologies compared to the WS-133A configuration of Minuteman. The activation of the 564th brought the number of active Minuteman squadrons up to twenty. Out of six wings, two (341st and 90th at F. E. Warren AFB, Wyoming) had four missile squadrons. The rest had only three.

The 341st SMW and its operational squadrons would control twenty LCCs, commanding 200 ICBMs, stretched over 23,000 sq. miles of land in Montana, making it the largest missile wing in the U.S. Air Force. Aside from these characteristics, the 341 SMW was the only Minuteman missile wing to operate all variants of the Minuteman missile (A, B, F, and G models) and operate both WS-133A and WS-133B command and control systems.

In 1976, the 341 SMW received remote targeting capability with the command data buffer (CDB) command and control (targeting) system for the Minuteman III. The CDB allowed rapid, remote targeting of the missiles if target priorities changed. Prior to the upgrade, maintenance crews brought new targeting tapes out to each LF to update the missile guidance computer. CDB retargeting allowed missile combat crews to transmit new target coordinates to individual missiles from the launch control center, leading to a faster retargeting capability.

END OF THE COLD WAR

In January 1988, SAC reactivated the 301st Aerial Refueling Wing at Malmstrom, providing the base its first flying unit since the 4061st departed nearly three decades earlier. SAC also provided administrative changes the following year with the addition of the 40th Air Division (40 AD) to the base over the 341 SMW and 301 ARW. In late 1989, the Cold War between the U.S. and Soviet Union began to thaw with the fall of the Berlin Wall. While the winds of change blew around the world, SAC adapted to face current and future threats. In August 1990, American forces deployed to Saudi Arabia for Operation Desert Shield. Aircrews from the 301 ARW provided aerial refueling to allied and coalition aircraft, and 341 SMW provided support personnel for security, civil engineering, and other services.

On September 1, 1991, the 341 SMW became the 341st Missile Wing (341 MW), and only weeks later, President George H. W. Bush took all LGM-30F Minuteman II and B-52 bombers off of strategic nuclear alert; however, all of Malmstrom's LGM-30G Minuteman IIIs remained on alert. The removal of the Minuteman II missiles was part of the ratification of the Strategic Arms Reduction Treaty (START). In November 1991, the missile inside LF Juilett-03 (J-03) was the first missile removed for treaty compliance. The entire process of removing all Minuteman II missiles took nearly three and a half years. On August 10, 1995, the missile inside LF Kilo-11 (K-11) was the final Minuteman II removed from the Air Force strategic inventory.

ADMINISTRATIVE PING PONG WITH NUCLEAR ASSETS

The end of the Cold War also directly led to the inactivation of SAC on June 1, 1992. In its shadow, two Air Force major commands (MAJCOMs) stood up: Air Mobility Command received the SAC's aerial refueling assets, and Air Combat Command received bombers and ICBMs. For a brief period of little over one year (June 1, 1992–July 1, 1993), Malmstrom AFB fell under Air Mobility Command's jurisdiction due to the 43d Air Refueling Wing; the inactivation of SAC also saw the 301 ARW inactivate and transfer its aircraft to the newly reformed 43d ARW. With one last sweeping change, Air Force Space Command (AFSPC) took control of all of the former SAC/ACC's missile units in July 1992. This led to the 43d ARW "downgrading" to a group and pushing host responsibilities back to the 341 MW. Little would administratively change for the 341st over the next sixteen years save two additional name changes: renaming to 341st Space Wing in 1997, and then reverting to 341 MW in 2008.

The heraldic symbol for the 341st Missile Wing with the
Latin motto, "World peace through air strength."

1

COLONEL EINAR AXEL MALMSTROM

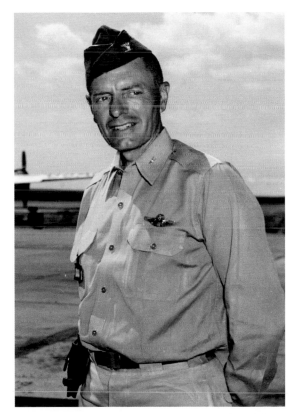

At the time of his death in 1954, Malmstrom was the vice commander of the 407th Strategic Fighter Wing at Great Falls Air Force Base, Montana. Respected by the local community for being a war hero and ace, Malmstrom endeared himself to Great Falls by donating rare Scandinavian books to the local library. After his death, U.S. Congressman Orvin Fjare (R-MT) asked Secretary of the Air Force Harold Talbott to rename the base in his honor, so it was renamed Malmstrom Air Force Base on October 1, 1955, and formally dedicated in June 1956. (*341st Missile Wing History Office*)

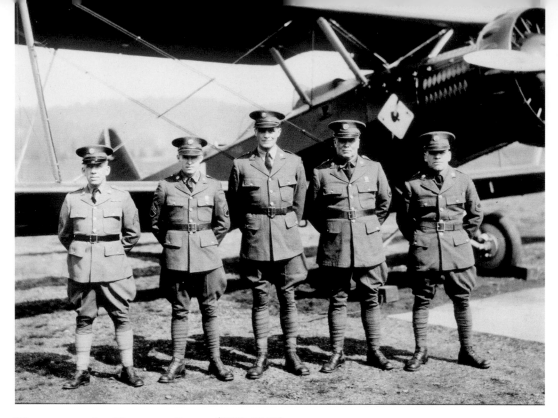

WASHINGTON AIR NATIONAL GUARD (1929–1940): On May 12, 1929, Malmstrom enlisted in the Washington Air National Guard's 116th Observation Squadron, one of the twenty-nine original National Guard flying squadrons. At the time of Malmstrom's enlistment, the unit was tasked with performing aerial surveys that would later assist in the building of the Grand Coulee Dam. In the image above, Malmstrom (center) wears two chevrons, indicating his corporal (enlisted) rank. Malmstrom became a commissioned officer in May 1931 and entered flight training soon after. Below, he is pictured with other 116th members (fourth from the right) wearing his aviator's leather flying jacket. In both images, personnel pose in front of a Douglas O-2 observation plane that was flown by the 116th Observation Squadron from 1926 to 1934. (*341st Missile Wing History Office*)

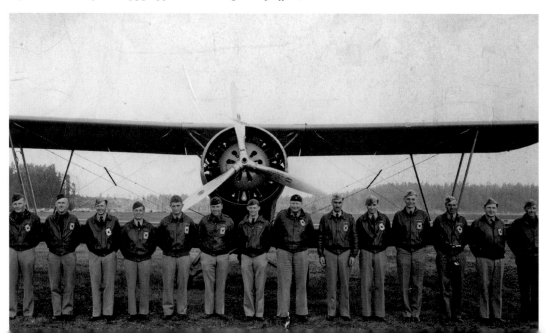

FLYING ACE: In May 1943, Lt.-Col. Malmstrom moved to the European Theater of Operations and assumed command of the 356th Fighter Group in November. Above, Malmstrom is pictured with other commanders (second row, fifth from the right) during a staff visit with Maj.-Gen. William Kepner, commanding general of the Eighth Fighter Command. Malmstrom's unit flew the P-47 Thunderbolt (below), supporting the Normandy landings and the Allied movement across Germany and France. The 356th had the highest ratio of losses to enemy aircraft in the Eighth Air Force. Malmstrom experienced this first-hand on April 24, 1944, when his P-47 (s/n 42-25513) was forced down by small arms fire over Haguenau, France, while on a strafing run. (*341st Missile Wing History Office*)

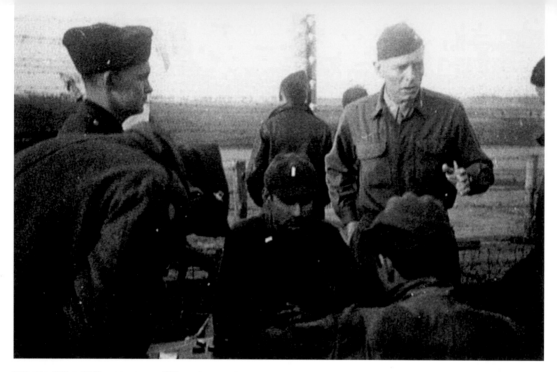

WORLD WAR II PRISONER OF WAR: On April 23, 1944, Col. Malmstrom was shot down over France on his fifty-eighth combat fighter mission and became a prisoner of war. As the senior Allied officer, he became the U.S. commander of the South Compound of Luftwaffe *Stalag Luft* 1 near Barth, Germany, from April 24, 1944, to May 15, 1945. In this leadership role, Malmstrom was responsible for the discipline, morale, and welfare of U.S. prisoners of war at the camp. The photo above shows Malmstrom chatting with other officers at Barth a few days after Germany's surrender. The *Stalag* was liberated by Russian troops on the night of April 30, 1945. The Allies celebrate "Victory in Europe" day on May 8, ending WWII in Europe. Below, Col. Malmstrom stands next to his camp's liberators. After being liberated, Malmstrom was awarded a Bronze Star for his able leadership during his incarceration. (*341st Missile Wing History Office*)

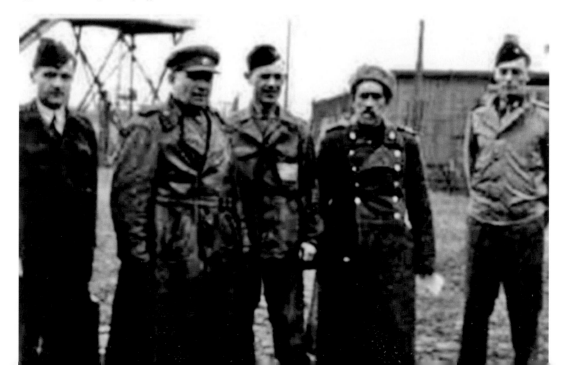

REMEMBERING A NATIONAL HERO: Returning to the U.S. in May 1945, Malmstrom became the air inspector for Barksdale Field (Louisiana), Biggs Field, (Texas), and Greenville Army Air Base (South Carolina). In February 1954, he was promoted to colonel (O-6) and assigned to Great Falls AFB (Montana) as the deputy wing commander, 407th Strategic Fighter Wing. Five minutes after takeoff, Col. Malmstrom was killed in a T-33 aircraft accident on August 21, 1954, approximately 1 mile west of the Great Falls Airport. Crash investigators concluded that Malmstrom's attempt to steer the malfunctioning T-33 away from a populated area likely cost him his life. Great Falls Air Force Base was renamed Malmstrom Air Force Base in his honor on October 1, 1955, and formally dedicated in June 1956. At the time of his death, Malmstrom was acting commander of the 407th Strategic Fighter Wing, as most of the wing personnel were overseas in Japan for temporary duty. Before moving his remains to Arlington National Cemetery in Washington, D.C., base personnel recognized Malmstrom with a marching procession (below) to a flight line service (above). (*341st Missile Wing History Office*)

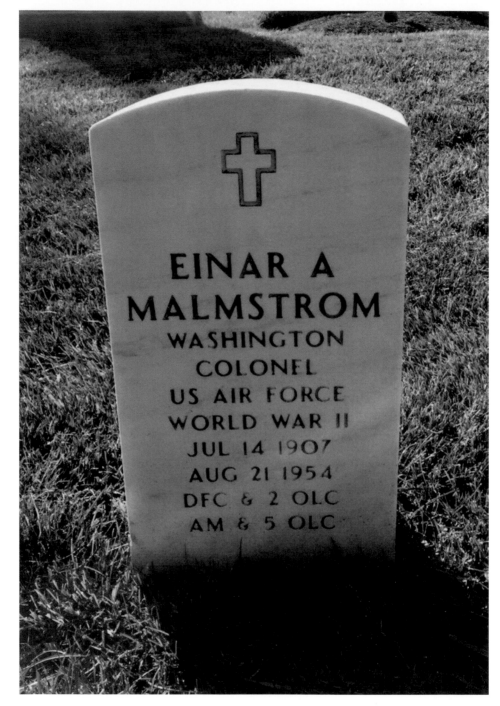

A Hero's Final Resting Place: Col. Einar A. Malmstrom was laid to rest at Arlington National Cemetery at Section 6, Site 9685-A, next to his beloved wife Kathryn. His headstone indicates he earned the Distinguished Flying Cross with two oak leaf clusters (three times received) and the Air Medal with five oak leaf clusters (received medal six times). Interestingly, his wife Kathryn's headstone erroneous indicates his rank as "Lieutenant Colonel," instead of "Colonel." Kathryn passed away in 1985, thirty-one years after her husband. (*Melyssa Web via BillionGraves.com*)

2

GREAT FALLS ARMY AIR BASE AND WORLD WAR II

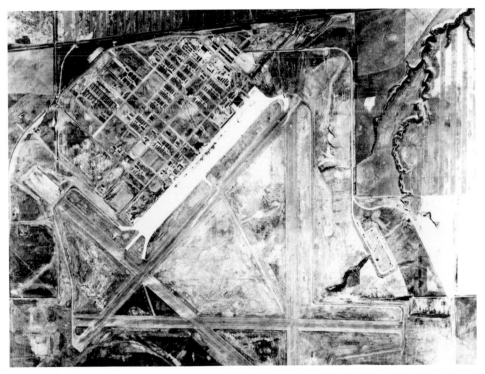

With the situation in Europe pushing toward all-out armed conflict, the Great Falls Chamber of Commerce desired a military presence in their community. In December 1937, Great Falls civic leaders urged Senators Burton Wheeler (D-MT) and James Murray (D-MT) to convince Maj.-Gen. Oscar Westover, chief of the Army Air Corps, to develop the Great Falls municipal airport into an army airfield. The Westover bid failed. In November 1939, the Great Falls Airport Commission appealed to Secretary of War Harry Woodring to locate an Army Air Corps squadron at Great Falls municipal airport. A survey team evaluated an area 6 miles east of the city, near the Green Mill Dance Club and Rainbow Dam Road, to house a heavy bomber training base. Construction on Great Falls Army Air Base began on May 9, 1942. (*341st Missile Wing History Office*)

FIRST FLIGHT INTO GREAT FALLS ARMY AIR BASE: A B-17 bomber, piloted by Col. Ford Lauer, landed at Great Falls Army Air Base on November 30, 1942. The following month, the base consisted of 2,650 acres with four runways (each 8,850 feet long and 300 feet wide), taxiways connecting to a concrete apron (which was 4,889 feet long and 500 feet wide), two hangars, an operations office, and a control tower (located on the northern edge of the apron). A spur of the Chicago, Milwaukee, St. Paul, and Pacific Railroad served the base and paved access roads connecting the base with US Highways 87 and 89. Below, early structures on GFAAB looked similar to this building—little more than timber, windows, and tarpaper. Rapid construction and cheap materials characterized these buildings for the burgeoning war effort. Not expected to stand for decades, many buildings such as these lasted well beyond their wartime expiration date. (*341st Missile Wing History Office*)

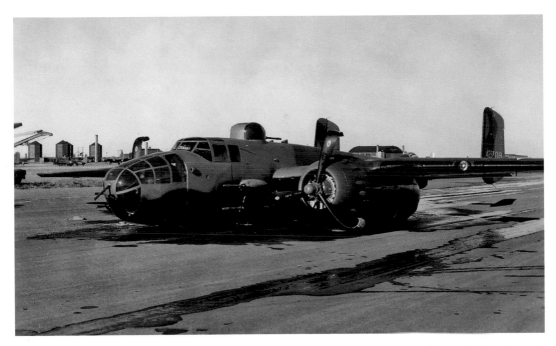

ANY LANDING YOU CAN WALK AWAY FROM: With the large number of aircraft transitioning through Great Falls AAB during the war years, accidents were bound to occur. Below, an A-20 Havoc tilts forward onto a collapsed landing gear. Weight balancing is critical for aircraft, both on the ground and in the air. Moving the center of gravity forward or aft along the fuselage, tipping or tilting is likely to occur. Contrasting with one landing gear collapsing is the threat of no landing gear deploying as seen above in this B-25 bomber on the runway. Note the bent propeller on the right side of the photograph. (*341st Missile Wing History Office*)

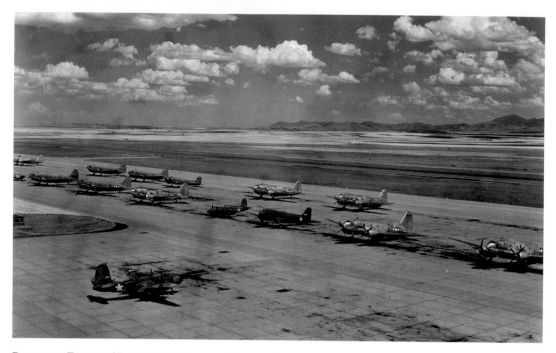

READY TO FLY THE NORTHWEST STAGING ROUTE: Two views of the Great Falls AAB runways show a number of aircraft (like the C-46 Commandos above) either awaiting modification or ready for hand-off to pilots to fly to Ladd Field in Alaska. The snow-laden runway (below) holds P-38s, P-63s, C-47s, B-25s, and a C-54 (far right), all destined to find their way to the Red Army's hands. The numbers of aircraft exchanged are staggering. For example, the Soviet air force received 861 B-25 bombers, while the aircraft still served with American forces. The B-25 was best known for the Doolittle Raid over Japan in 1942. (*341st Missile Wing History Office*)

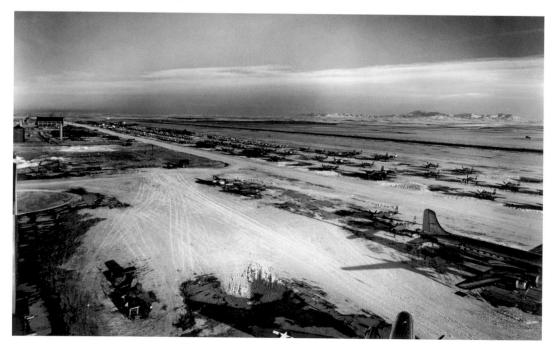

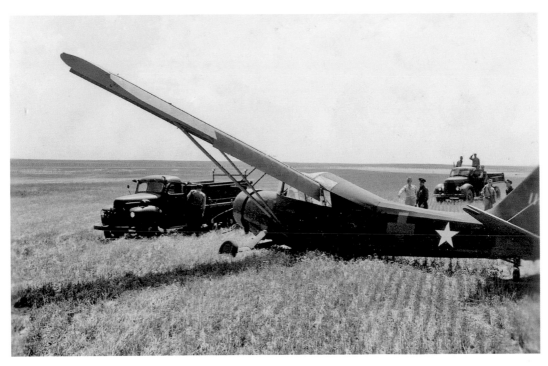

BIG SKY THEORY OF CRASHING: The unpopulated fields surrounding Great Falls and the rest of Montana provided a good place to crash land, but only when one is out of options. As seen in these photos, plenty of aircraft took damage after flights over Big Sky Country. Above, an O-49 Vigilant liaison aircraft is seen with a collapsed landing gear. The AT-6 Texan, below, has seen better days. Training bases included inexperienced crews with aircraft for instruction—accidents such as these, or worse, were bound to occur. (*341st Missile Wing History Office*)

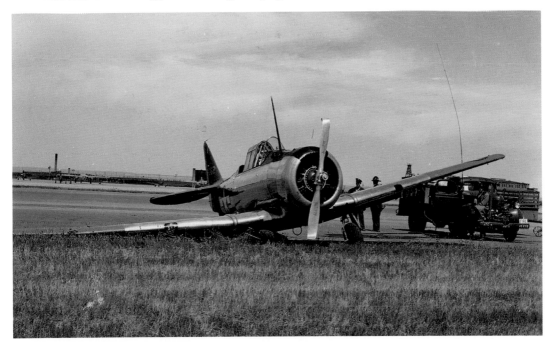

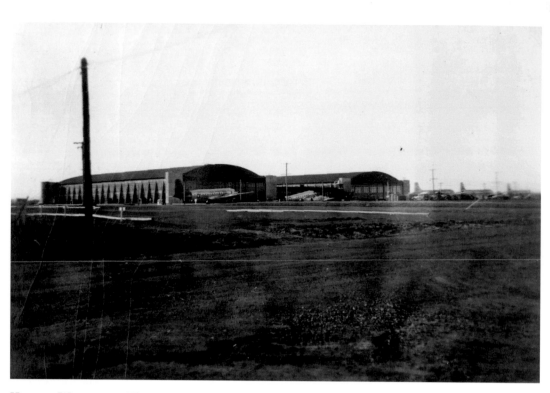

HOME IS WHERE THE HANGARS ARE: The B-17s that originally flew at East Base, and the follow-on aircraft, required ample space for construction, rebuilds, and repairs. Large hangars, such as these twin behemoths, were created at many army airfields around the country. As shown below, there was plenty of room to hold many aircraft "assembly-line" style for workers to finish them before handing them off to the Soviet pilots during the Lend-Lease years. A-20 Havoc bombers line the sides, and C-47s fill the rear of the hangar. (*341st Missile Wing History Office*)

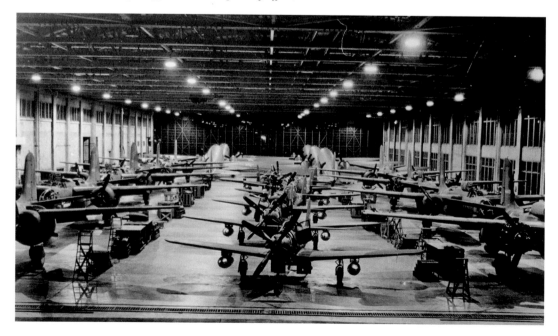

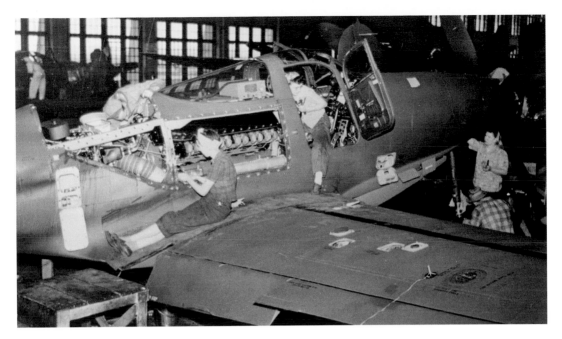

ROSIE RIVETS RED ARMY AIRCRAFT: Female mechanics strip down a P-63 for final outfitting before its departure to Russia. After Congress passed the Lend-Lease Act in March 1941, extending aid to Britain and the exiled government of Poland, representatives from the Soviet Union requested aid shipments also. Soviets observed American aircraft factories (no doubt also collecting intelligence for their industry) building planes for future shipments to the Soviet Union. Early Lend-Lease routes transited through and over the North Atlantic. Bad weather and Nazi submarines were major threats to ferry crews and cargo shipments, respectively. The Northwest Staging Route through Canada and Alaska, then over to Russia, proved to be a safer traveling course. Below, a crew works through the final processing of a C-47 Skytrain in June 1945, destined for the Red Army. (*341st Missile Wing History Office*)

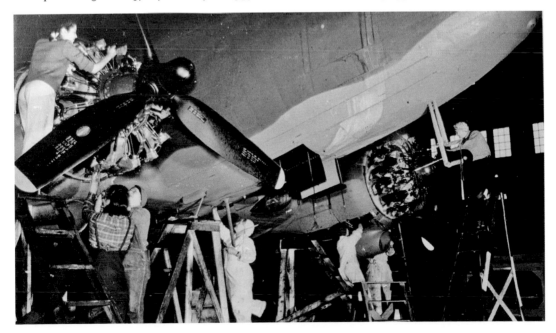

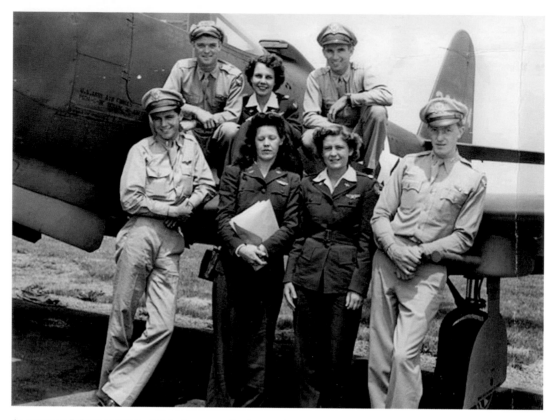

AMERICAN WOMEN WARRIORS: A group of exhausted WASPs pose in service dress with some male aircrew members on the wing of a P-63 Kingcobra. After flying into Great Falls, the female aircrew members relaxed and enjoyed their limited time on the ground. Often, the WASPs were bunked in WAC barracks. Below, WACs at Great Falls AAB prepare Christmas dinner inside the Mess Hall, December 1944. (*341st Missile Wing History Office*)

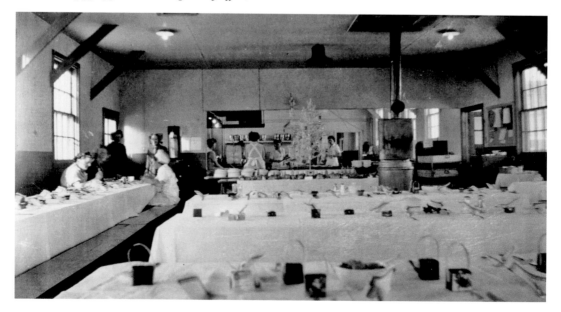

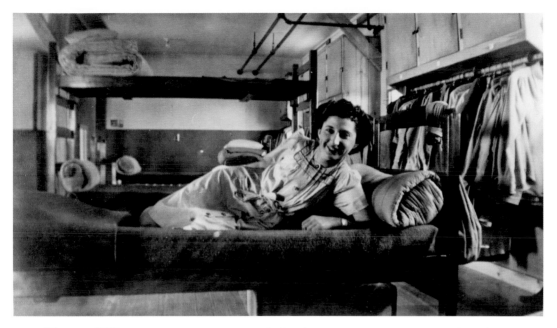

WARTIME R&R: Great Falls AAB also included a detachment of Women's Army Corps (WACs) members, providing critical functions for the smooth operation of airbase operations. WACs worked as weather forecasters, electrical specialists, sheet metal workers, link trainer instructors, control tower specialists, and airplane mechanics. The WAC in her bunk, above, shows the Spartan accommodations provided to female military members in Montana. Below, WAC Marty "The Mighty Hunter" takes a moment to pose in front of her vehicle near Dillon, Montana. From World War II to the present day, military members take advantage of Montana's unique charm, ranging from hunting to camping and touring Glacier National Park. Big Sky Country was beautiful, and these ladies did not miss a chance to explore. (341st Missile Wing History Office)

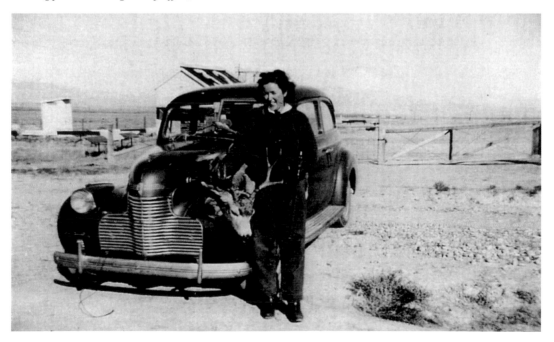

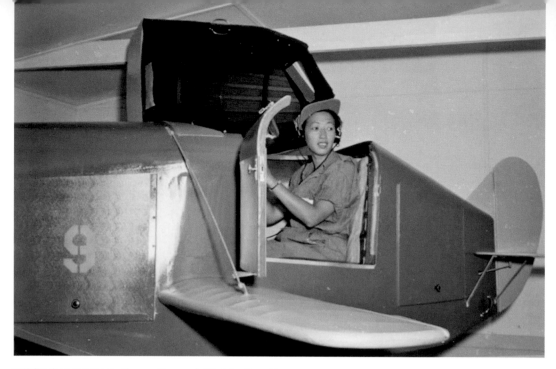

WASP Casualty at Great Falls AAB: The first Chinese-American pilot in the U.S. military, Hazel Ah Ying Lee, WASP Class of 43-4, sits inside a Link trainer. Lee earned her pilot's license in 1932 and went to China the following year, hoping to join the Chinese Air Force to fight Japanese invaders. However, the Chinese did not allow women pilots, so Lee returned to the U.S. in 1938. Historian and fellow WASP Byrd Howell Granger describes Lee as a "favorite with just about everyone." As a joke, Lee would inscribe Chinese symbols on the tails of her pursuit aircraft, often telling young men she named her plane after him. The inscribed "words of adoration" were rarely complimentary, as Granger recounts, with one plane dubbed "Fat Ass," after an overweight ground officer. Lee was married to Maj. Louie Yim-qun, an American-born pilot with the Chinese Air Force. On November 23, 1944, Lee was approaching Great Falls AAB in a P-63 Kingcobra only days off the Bell Factory assembly line. Due to miscommunication by the control tower, Lee heard the tower's misdirected call to "Pull up, Pull up!" She collided with another P-63 above her and fell with the flaming wreckage. Lee survived two days with extreme burns but succumbed on November 25, 1944. It took nearly a year after her death to find her family and return her remains. Hazel Ah Ying Lee was one of thirty-eight WASPs killed during the program. (341st Missile Wing History Office)

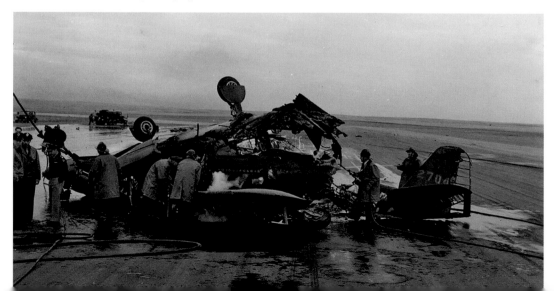

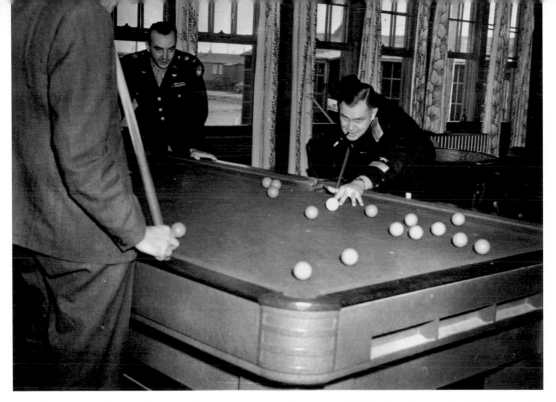

SOVIETS AT GREAT FALLS AAB: Soviet officers enjoy a game of billiards at Great Falls AAB. During the Lend-Lease program, Soviet liaison officers lived in the hotels downtown, and it was common to see Russians at the base, as well as downtown inside Great Falls. Red Army pilots wore distinctive green and black uniforms with high boots and britches. Below, American and Soviet allies pose for a picture beside a C-47 destined for Russia. (*341st Missile Wing History Office*)

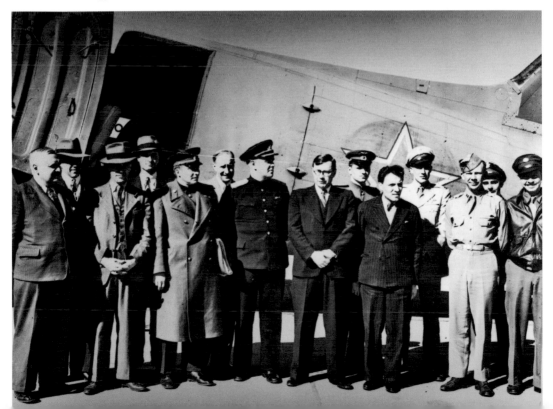

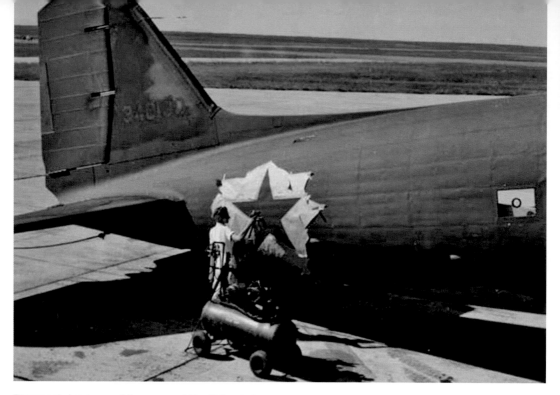

PAINTING AIRCRAFT MARKINGS: Miss Helen Roberts, a civilian employee, paints the Red Army star on the rear fuselage of a C-47 Skytrain (above). Aircraft livery is a set of comprehensive insignia comprising color, graphic, and typographical identifiers that show who is flying the aircraft. National air forces each have unique identifiers to assist in determining if a fellow zoomie is "friend" or "foe." Since Great Falls was the embarkation point for aircraft leaving the continental United States, American ground crews applied Red Army markings before entering Canada along the Northwest Staging Route. Below, a C-47 and B-25 await departure from Montana. Aircraft delivery at Ladd Field in Alaska ended the Northwest Staging Route, but conversely began the first leg of the Alaskan–Siberian air road (ALSIB) to the Soviet Union. (*341st Missile Wing History Office*)

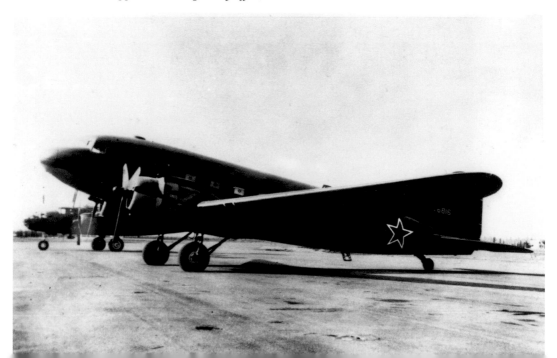

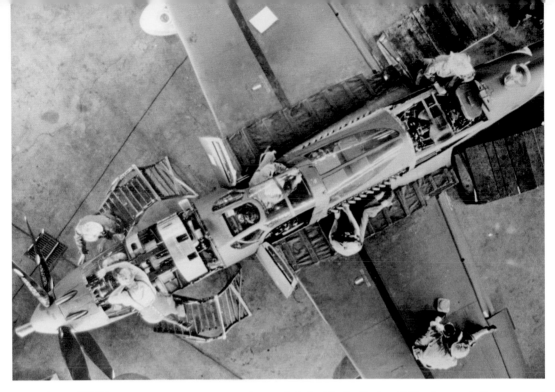

AFTER V-E DAY: A maintenance crew works on a P-63 inside the final outfitting hangar in June 1945. At this point in the war, Victory in Europe (V-E) was declared on May 8, 1945, and the Potsdam Conference was still over a month away. As of June 1945, the Soviets had not yet declared war on the Japanese Empire. Due to the Soviet–Japanese Neutrality Pact signed in April 1941, the Soviets interned Allied aircrews who landed in Soviet territory following bombing operations against Japan. U.S. airmen held in the Soviet Union under such circumstances were usually allowed to "escape" after a period of time. As part of the Lend Lease agreement, Great Falls AAB teams were still preparing aircraft for the Soviets during early summer 1945, such as the crashed P-63 shown below. (341st Missile Wing History Office)

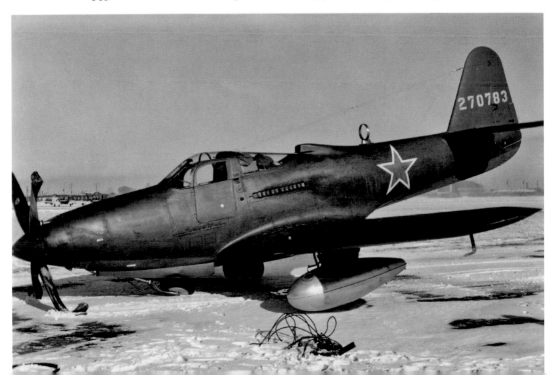

SKYMASTER UP AND SKYMASTER DOWN: A C-54 Skymaster attempts a landing at Great Falls Air Force Base. Due to many synergistic factors, Great Falls AFB was selected to train aircrews for the Berlin Airlift. All replacement aircrews during the Berlin Airlift were trained in Montana. The skies were filled with war-experienced aircrews altering their *raison d'être* from defeating the Germans to helping to save them, by airlifting supplies to the city of Berlin through Tempelhof Airport. On January 26, 1950, a Douglas C-54 Skymaster (s/n 42-72469) departed from Anchorage (AK), bound for Great Falls AFB. Two hours into an eight-hour flight, ground controllers lost contact with the aircraft over Snag, Yukon Territory (Canada). Considered the largest group of American military personnel ever to go missing, no remains of the forty-five people or the aircraft have surfaced. American and Canadian rescue crews mounted the largest search ("Operation Mike") involving 7,000 personnel searching 350,000 sq. miles of wilderness. On February 20, 1950, officials canceled the search in lieu of supporting another accident: a lost B-36 Peacemaker over British Columbia carrying a Mark IV nuclear bomb. GFAFB's 1701 Air Transport Wing personnel supported the C-54 search effort from the south. (*341st Missile Wing History Office*)

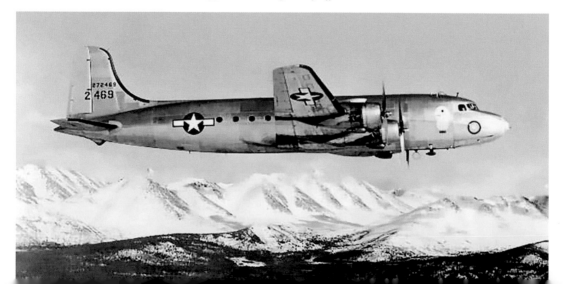

3

Cold War in the Northern Tier

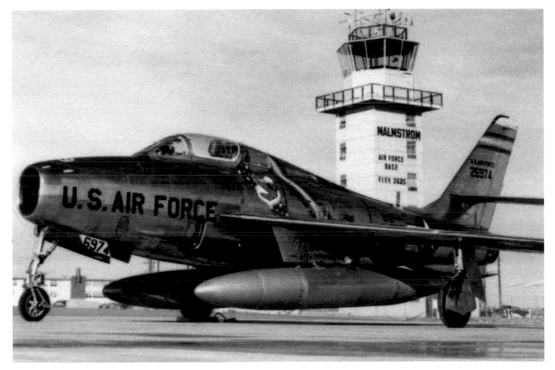

An F-84F Thunderstreak sits on the Malmstrom parking apron. During October 1955, the 407th Strategic Fighter Wing finished converting from the F-84G Thunderjet to the F-84F Thunderstreak starting the process seven months earlier. The F-84 was the first production fighter aircraft to utilize inflight refueling and the first fighter capable of carrying a nuclear weapon. The 407 SFW's location at Great Falls was not an accident—with the threat of a Soviet attack coming via air routes from the North, and the requirement to protect U.S. bombers (and their KC-97 aerial refueling tankers) heading toward the Soviet Union, Great Falls' high latitude and in-place infrastructure met the requirements for fighter bed down. (*341st Missile Wing History Office*)

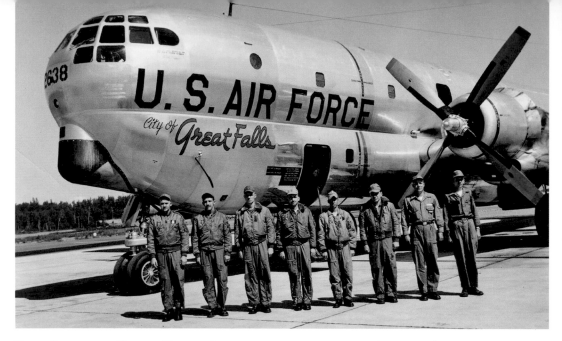

First Generation Tanker Toads: The crew of "The City of Great Falls" (s/n 52-2638), the first KC-97G aerial-refueling tanker at Malmstrom, poses outside their aircraft. The 407th Air Refueling Squadron flew KB-29s from 1953 through 1957 before exchanging them for KC-97s. The aircraft's lineage was derived from the B-29 Superfortress bomber through the C-97 Stratofreighter cargo-carrying variant. While the Air Force's first aerial refueler, the KB-29, fed aircraft through a probe-and-drogue system ("flying basket"), the KC-97 used a flying boom to hook up to receiving aircraft. The difference in fuel flow between the probe-and-drogue and flying boom was analogous to using a drinking straw or drinking out of a water hose. The KC-97 flew with the U.S. Air Force from 1950 through 1978, when the final aircraft were retired. Malmstrom's museum has a KC-97L (53-0360) repainted as the "City of Great Falls." (*341st Missile Wing History Office*)

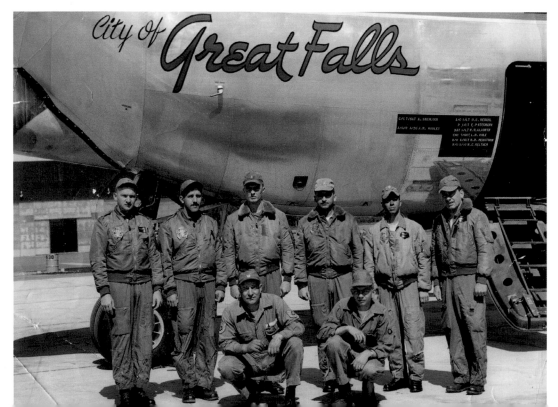

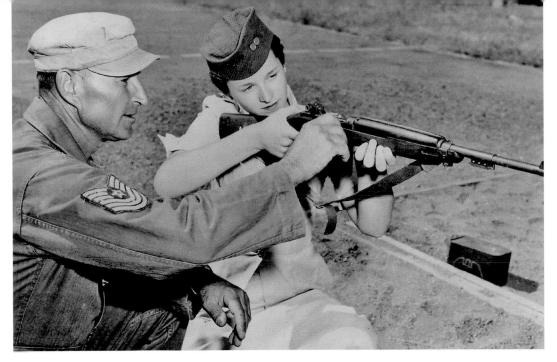

EATS, SHOOTS, AND LEAVES: An unidentified master sergeant instructs Civil Air Patrol Cadet Roberta Wood on proper shooting techniques firing an M-1 carbine. The Civil Air Patrol (CAP) is the USAF Auxiliary, assisting with emergency services such as search and rescue, aerospace education for the general public, and youth programs. Many CAP units participate in activities with active Air Force personnel, such as the training shown above. Below, seven unidentified women "man" their stations at the base chow hall in the late 1950s. Before the addition of commercial restaurants on military bases, the chow hall was the main facility for feeding the troops. Changes from the World War II-era "Kitchen Patrol" (KP) duty brought a friendlier environment to the eating experience. In the modern era, the term dining facility, or DFAC, has replaced "chow hall." (*341st Missile Wing History Office*)

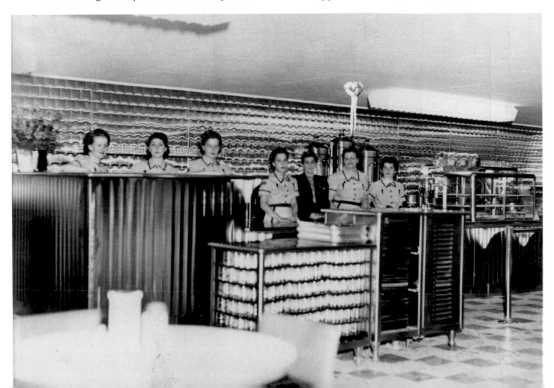

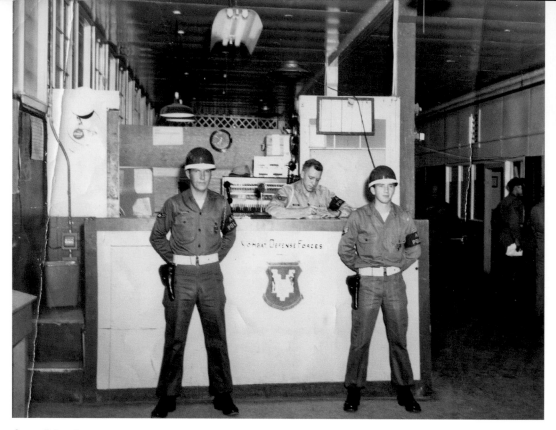

COLD WAR DEFENSE POSTURE: Members of the 341st Combat Defense Squadron stand in front of the sergeant's desk. Malmstrom's eclectic collection of critical assets—tankers, interceptors, SAGE blockhouse, and missile facilities—required a trained force of security specialists: the air police cadre. Just like their operations and maintenance counterparts, Security Forces members today hold "guard mount," to pass along information prepare for their shift in the missile complex. The Malmstrom SAGE Direction Center (DC-20) (below) included equipment to interface with Gapfiller and long-range radar sites, Nike missile batteries, interceptor forces, and air route traffic control centers to warn of air attacks on North American soil. First built in 1959, DC-20 became operational in early February 1960 and stood watch until March 1, 1983, with the same vacuum tube FSQ-7 computer. The building presently houses the headquarters for the 341st Missile Wing. (*341st Missile Wing History Office*)

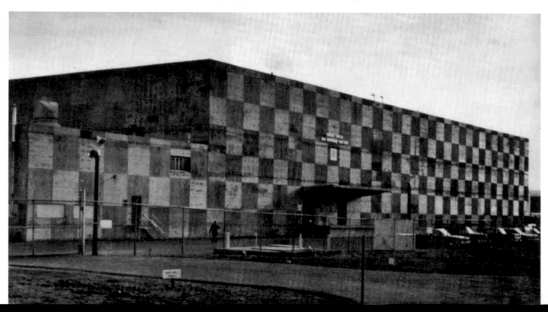

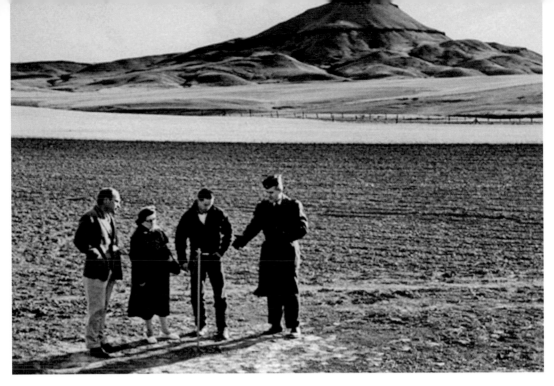

"Let's Dig Here!": An Air Force officer shows three unidentified individuals a survey marker for the future location of LF Alpha-11 (A-11) in 1960. During the start of the Minuteman program, the U.S. government had to lease plots of land from local farmers to build the launch control facilities (later, missile alert facilities) and the underground silos that held the missiles. Often the leases were made for ninety-nine years for extremely low prices. While the acreage holding the missiles and support equipment were manageable, the interconnecting network of copper cables stretched throughout the countryside for hundreds of miles. As seen below, an industrial-sized trencher digs a trough for the hardened intersite cable system (HICS). Malmstrom's cable affairs section maintains and manages the HICS right-of-way records database for over 2,000 landowners that have buried cables on their property. (*341st Missile Wing History Office*)

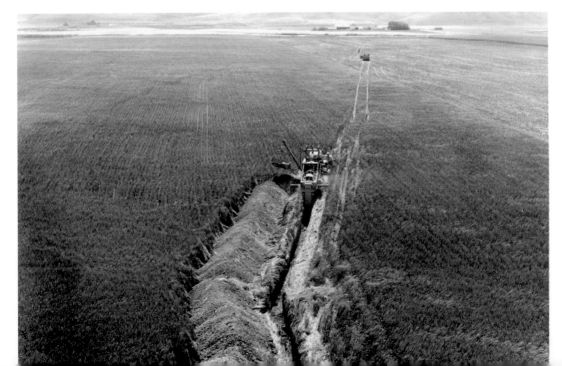

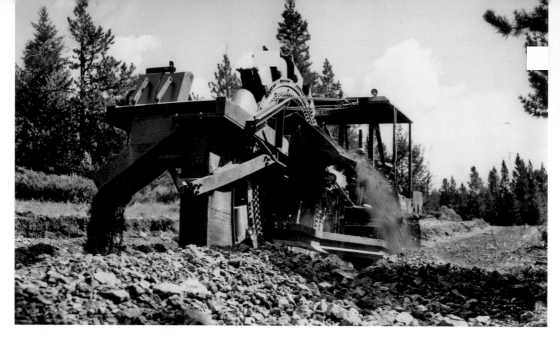

INTERCONNECTED COPPER WEB: Many thousands of feet of copper cable were emplaced inside roadside trenches like this one seen above. The giant wooden spool on the truck carried the HICS cable, which is made of strands of copper wire encased inside a sheath. While this may seem no different than normal telecommunication cables, HICS lines are pressurized to allow rapid troubleshooting when the cable is cut. Narrowing down the problem areas allows cable crews to affix splices to restore connectivity. Below, the sharp blades on the trenching machine and the aggregate forming around it on the ground illustrate Montana's difficult geology, one of the key factors in locating Wing One in the state. The 341MW HICS maintenance section is responsible for maintenance of the cable's pneumatic pressurization and monitoring system, over 2,100 miles of cables and 7,200 splice cases buried across the 13,800-sq. mile missile complex. (*341st Missile Wing History Office*)

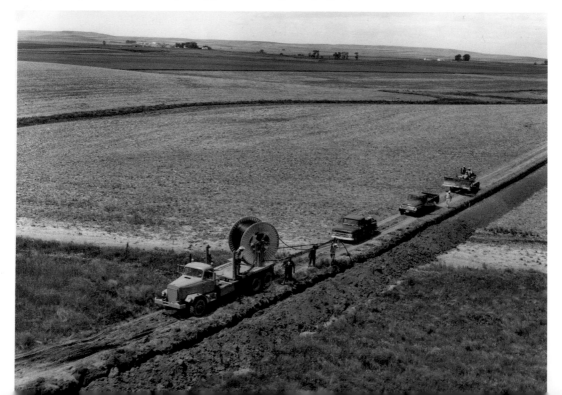

BUILDING FOR A SECURE FUTURE: Early construction of one of Malmstrom's twenty LCCs shows the simple design of the underground facility. The concrete shaft on the left housed the elevator shaft for crews to return to ground level ("topside"). The dark brown capsule-shaped object is the metal-reinforced LCC, soon to be surrounded by concrete. While blast hardness numbers are classified, the steel and concrete reinforced capsule provide better protection than early first-generation ICBM systems. Having the crews located underground did not hurt either. The early LCC designs for Wing One capsules did not include an underground launch control equipment building (LCEB) for support equipment. However, the last Minuteman squadron (564 MS) built did include an underground support building housing a diesel generator and air filtering equipment. The image below shows an aerial view of LCC construction. The capsule and elevator shaft sit inside the excavation pit, which will be filled in after construction. The buildings to the right are contractor support facilities in modular buildings. These did not remain on-site, being removed after construction was complete. Simultaneous trenching toward the LCC allowed for HICS connectivity before backfilling the dirt. (*341st Missile Wing History Office*)

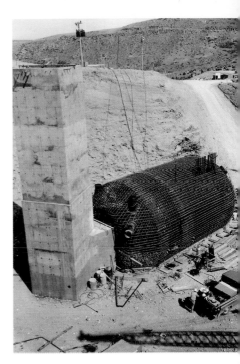

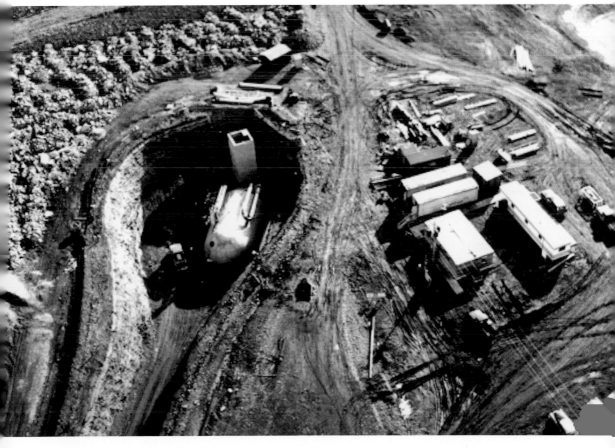

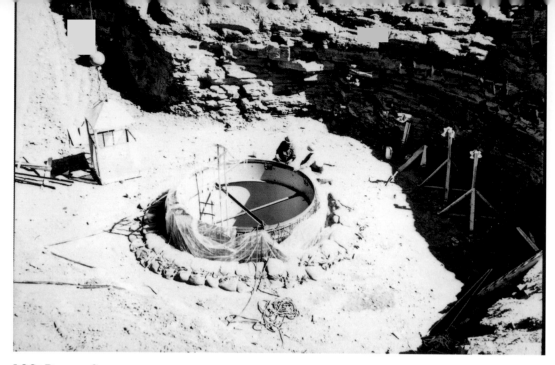

LCCs During Construction: These two images show the Minuteman launch tube contrasting both before and after installation. The launch tube, as seen transported above, consisted of a reinforced metal sleeve that would hold one Minuteman missile. Cranes lowered this metal sleeve into the LF excavation hole before the installation of the launcher equipment room (LER). The LER held the support and monitoring equipment for the Minuteman missile, as well as connective lines into the HICS network. At the height of the Cold War construction boom, some bases were completing one launch facility per week. Since Minuteman was a defense priority for the Kennedy Administration, LF and LCC construction provided many jobs to construction workers and an economic boom to the local economies. The Minuteman program office passed along lessons learned at Malmstrom to other Minuteman wings, resulting in significant changes between wing LF and LCC configurations. Attempts to standardize missile capabilities and increase nuclear hardness (ability to withstand nuclear blast effects) resulted in force modification and silo upgrade programs. (*341st Missile Wing History Office*)

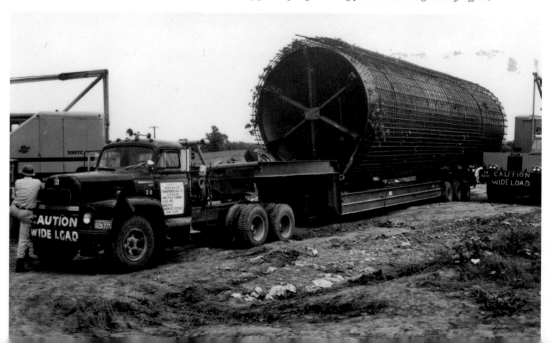

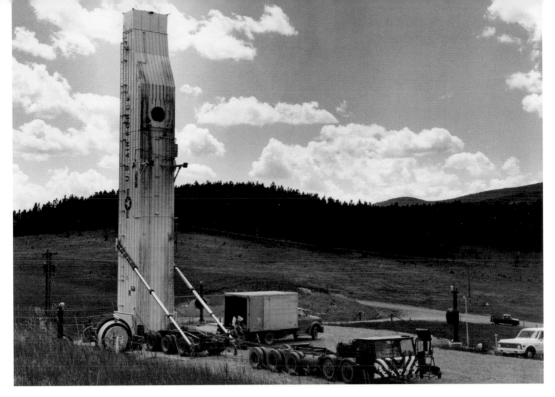

ACE IN THE HOLE: A transporter erector emplaces a SM-80A Minuteman IA missile inside Alpha-04 in 1962. This was one of the first Minuteman missiles on alert in the United States. During the Cuban Missile Crisis, Alpha flight was being prepared for handover to the Air Force as fully capable missiles. As the crisis abated, the remaining missiles in Alpha flight were tested thoroughly before being handed over to the military. Below, Malmstrom AFB has a ceremony recognizing the handover of Oscar flight from Air Force Systems Command to Strategic Air Command. Handover recognizes the weapon system is fully operational and no longer requires day-to-day contractual or depot assistance to operate. (*341st Missile Wing History Office*)

FIRST GENERATION MISSILEERS AND MAINTAINERS: An unidentified captain of the 10th Missile Squadron coordinates with a missile maintenance team out at one of "his" LFs in the flight area. Most notably, the crew is wearing white coveralls as their duty uniform. Early missile ops and maintenance members wore these out at Atlas, Minuteman, and Titan sites. The coveralls were similar to painter's coveralls but with heavy starching, provided by the base laundry facilities. Below, maintenance members receive a briefing before traveling out into the missile complex. This pre-departure briefing provides up-to-date information on road conditions, upcoming missile repairs, and weather forecasts. After receiving their maintenance briefing, the teams would collect their tools from the tool crib, requisition their vehicles, and head out to the appropriate LF or LCC. (*341st Missile Wing History Office*)

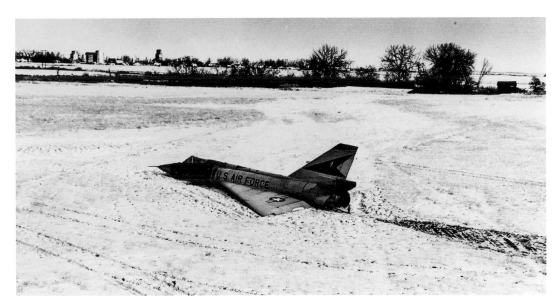

MONTANA'S CORNFIELD BOMBER: F-106 Delta Dart, s/n 58-0787, (above) occupies a special place in Montana's military history. On February 2, 1970, during a routine training flight for aerial combat maneuvers, 1Lt. Gary Faust of the 71st Fighter-Interceptor Squadron, entered into an unrecoverable flat spin. Faust eventually ejected at an altitude of 15,000 feet and watched as the aircraft righted itself. As Faust watched during his parachute journey toward the ground, 58-0787 continued flying with a slow descent and eventually soft-landing in a farmer's field. A local sheriff approached the jet with the engine still idling. Malmstrom command post controllers informed the sheriff to let the fuel run out, which happened an hour and forty-five minutes after landing. Damage to the aircraft was minimal and it returned to service after repairs. Faust was able to fly 58-0787 again in 1979 during training at Tyndall AFB, Florida. The aircraft, nicknamed the "Cornfield Bomber," arrived at the National Museum of the Air Force in Dayton, Ohio, in August 1986, where it is still on display (below). (*National Museum of the United States Air Force*)

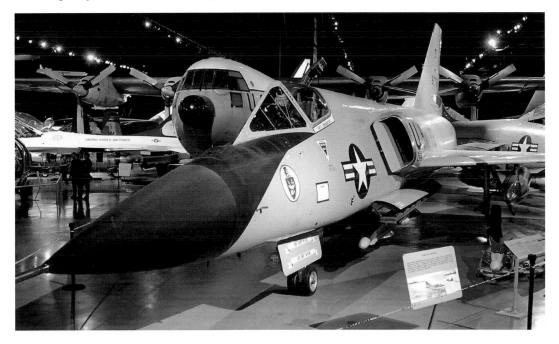

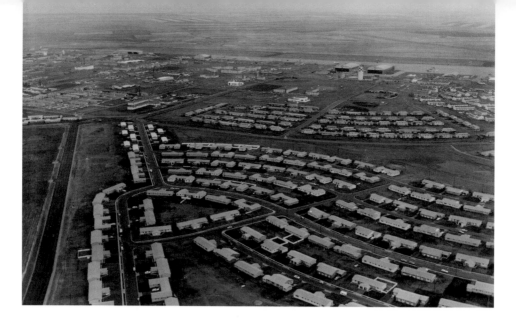

THE SIXTIES AND SEVENTIES IN THE NORTHERN TIER: The view of Malmstrom AFB in 1965 shows base housing on the northwest side of the base. Throughout the Cold War, military installations contained housing units for the families of Air Force members. Two notable construction projects providing living quarters provided by the government, instead of families living "off the economy," subject to issues such as unscrupulous rent hikes. These homes, dubbed Wherry and Capehart after the congressional acts that authorized construction, were fixtures on hundreds of military bases over nearly seven decades. Below, an armed air police sentry walks a perimeter around a parked KC-135A on the Malmstrom flight line. KC-135s occupied a unique place inside SAC's single integrated operations plan (SIOP), the overarching nuclear war plan. When alert bombers take to the skies, the short time for takeoff may have prevented full refueling for their SIOP missions. Aerial refueling offered the opportunity to "top off" the bombers' fuel tanks before heading over the North Pole. Malmstrom's geographic position gave planners an excellent location to preposition northern tier tanker aircraft. (*341st Missile Wing History Office*)

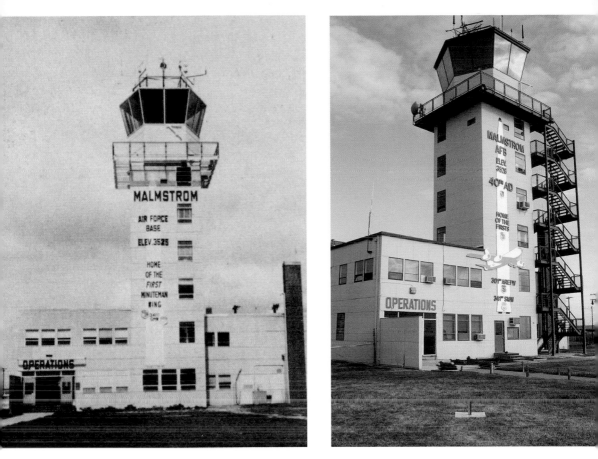

BIG SKY AIR TRAFFIC CONTROL: Comparison shots of Malmstrom's Air Traffic Control tower in the 1960s and the 1980s. Malmstrom's pride beams to new arrivals at the airfield, announcing the base as "Home of First Minuteman Wing" (above left). The elevation of the base is listed as 3525 feet above sea level. The later shot, above right, states Malmstrom as the "Home of the Firsts," with the 40th Air Division, 341st SMW, and 301st Air Refueling Wing. (*341st Missile Wing History Office*)

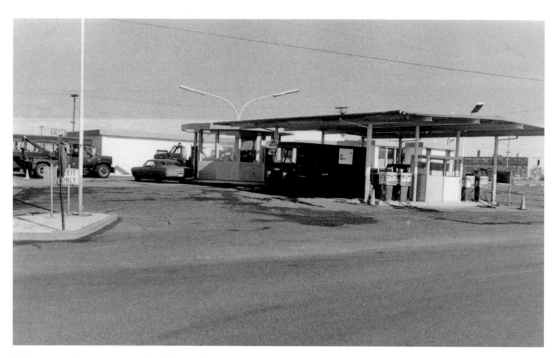

A Slice of Americana, Air Force Style: In the 1970s, shared facilities, such as the gas station and auto (and wood) hobby shop, provided a sense of (albeit skewed) normalcy for military members and their families living on Malmstrom. Commander-in-Chief Strategic Air Command (CINCSAC) General Curtis LeMay, an automobile enthusiast, encouraged the development of do-it-yourself garages on SAC installations. These "auto hobby shops" provided tools and clean maintenance bays for military members to work on their personal vehicles. Other recreational facilities, such as rod-and-gun clubs for fishing and hunting enthusiasts, soon followed. The co-located woodshop at Malmstrom allowed members to use tooling to create their own handicraft masterpieces with loaned tools and machinery. Base services such as these provided recreational outlets for the men and women operating America's nuclear deterrence forces. (*341st Missile Wing History Office*)

Strategic Modernization

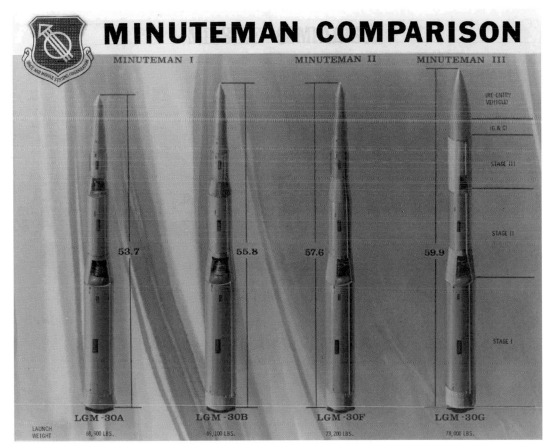

MINUTEMAN COMPARISON

MINUTEMAN I	MINUTEMAN II	MINUTEMAN III

53.7 55.8 57.6 59.9

PRE-ENTRY VEHICLE

(G. & C)

STAGE III

STAGE II

STAGE I

LGM-30A	LGM-30B	LGM-30F	LGM-30G

LAUNCH WEIGHT 68,900 LBS. 69,100 LBS. 73,200 LBS. 78,000 LBS.

The Minuteman comparison chart provides the most basic dimensions of the LGM-30 missile family. The measurements on the first and second stages belie an extraordinary fact: aside from the serial numbers, fuel mixture composite and geographic placement around the country, these stages are indistinguishable across the entire Minuteman family. Malmstrom's 341st was the only missile wing to field all four Minuteman variants. (*341st Missile Wing History Office*)

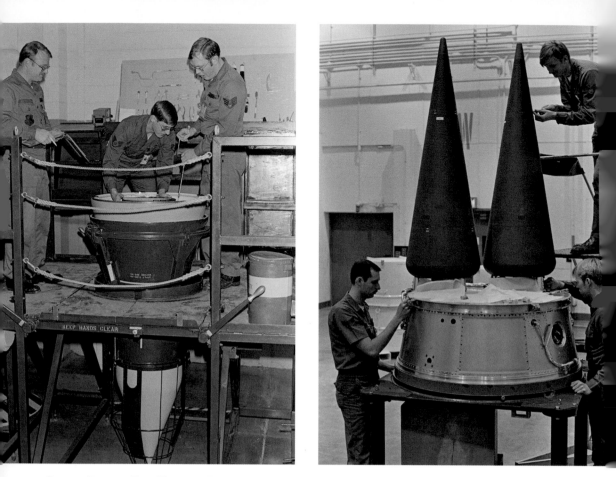

SHARP, POINTY END TOWARD ENEMY: Malmstrom maintainers inspect the "business end" of two different Minuteman missiles in the mid-1980s. In the image above left, three technicians work on the Mark 11 warhead of a LGM-30F Minuteman II missile. That missile variant carried a single warhead in the megaton range. Access to the physics package is through the bottom because the top of the Mark 11 contains the ablative shielding for atmospheric re-entry. Above right, technicians inspect warheads in the Mark 12 family for a Minuteman III. One of the noticeable changes between the "F" and "G" models was the inclusion of multiple independent re-entry vehicles (MIRV), allowing the missile to carry up to three independently targeted warheads. This provided the Minuteman III a three-fold increase in target coverage. The trade-off was a lighter warhead with a lower yield in the kiloton range. While public sources may state "definitive" numbers for blast yields, the Air Force does not disclose nuclear warhead specifics in the interest of operational security. (*National Archives and Records Administration*)

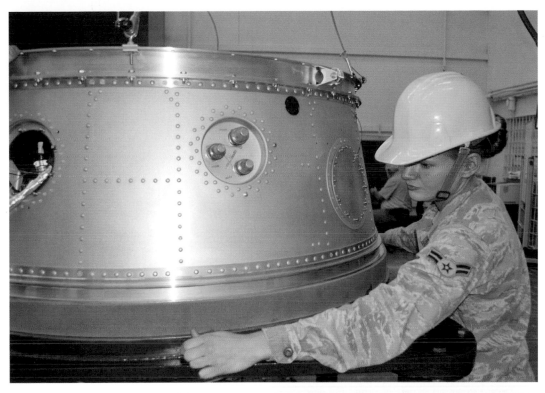

INNER WORKINGS OF AN ICBM:
Airman First Class (A1C) Jennifer Cook,
341st Munitions Squadron technician,
removes safety pins from a maintenance
stand holding up payload support
structure (PSS) for a Minuteman missile.
The structure holds Mark 12A re-entry
vehicles when placed atop the propulsion
system rocket engine (PSRE), the
Minuteman's unofficial "fourth stage."
The PSRE and corresponding payload
support structure are an integral part
of the Minuteman III's MIRV capability
as originally designed in the late 1960s.
The miniature mural (right) shows how
the Mark 12 re-entry vehicles sit atop the
PSS. (*341st Missile Wing Public Affairs Office*)

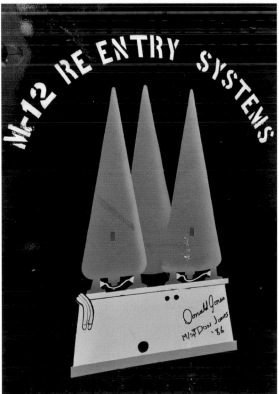

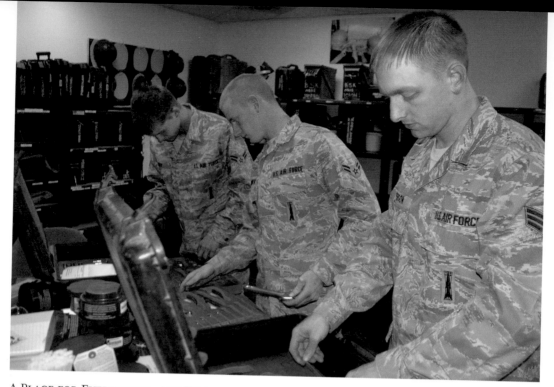

A PLACE FOR EVERYTHING, AND EVERYTHING IN ITS PLACE: A1C James Kirby, Josh Quintal, and Senior Airman (SrA) Craig Roberson (left to right), 341st Missile Maintenance Squadron tool room technicians, inspect tool kits used by electromechanical team members. During high-profile events, such as the yearly code change, tool room technicians will inspect and clean every tool kit as teams return from the field. Below, SrA Shaquille Stephens, 341st Missile Maintenance Squadron maintenance technician, looks through kits of tools. Tool kits are inspected daily to ensure maintainers have the correct tools to perform proper maintenance. Due to the sensitivity of the weapon system, technical orders provide no leeway when the correct tools are not available. (*341st Missile Wing Public Affairs Office*)

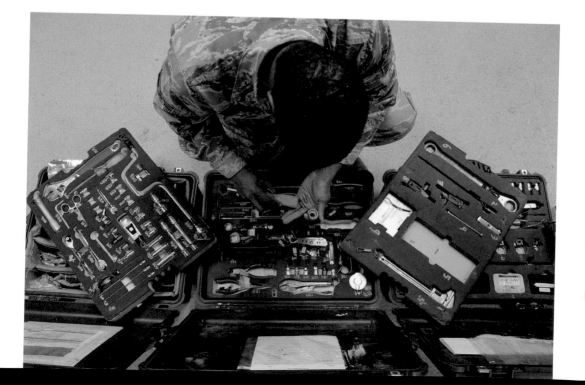

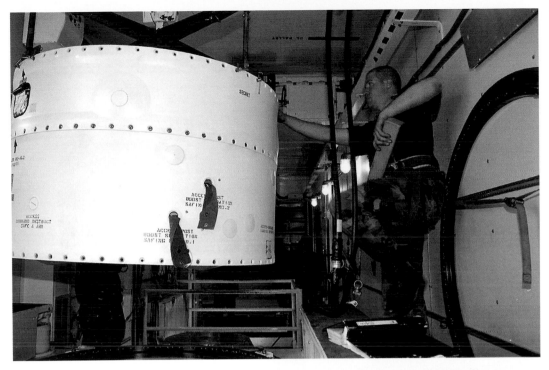

Next Generation Upgrades:

Inside a payload transporter van, A1C Roger Ridley, 341st Maintenance Squadron, lowers a missile guidance set onto the new booster inside LF Hotel-02. To keep the Minuteman weapon system viable for the foreseeable future, upgrades to the booster and guidance system were necessary in the early 2000s. Dubbed the guidance replacement program (GRP) and propulsion replacement program (PRP), this modern technology upgraded accuracy and flexibility inherent in the Minuteman system since its inception in the 1960s. Right, two maintainers install the re-entry shroud atop a newly converted GRP/PRP sortie. (*341st Missile Wing Public Affairs Office*)

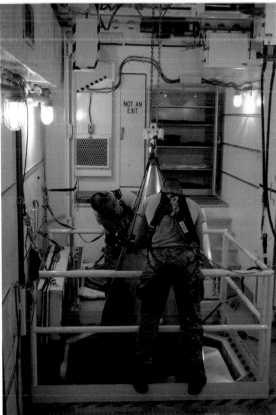

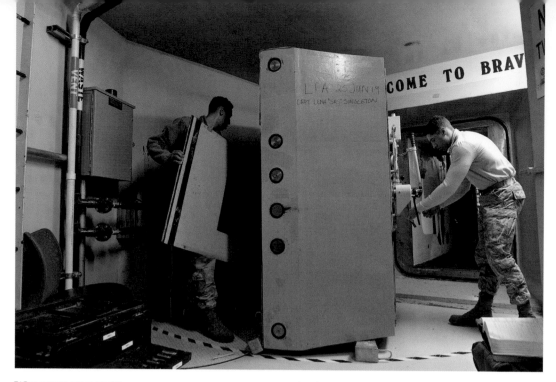

WELCOME TO THE UNDERGROUND: A1C Anthony White (left) and SrA Mark McCormick (right), 341st Missile Maintenance Squadron survivable systems team members, perform maintenance on a LCC blast door at Bravo-01. The team performs critical LCC maintenance, including repairs for the blast door. The door protects the missile combat crew from overpressure experienced during a nuclear blast. Inside the LCC, 2Lt. Wesley Griffith (left) and 1Lt. Katie Grimley (right), from the 10th Missile Squadron, work on coordinating maintenance teams for the base's annual code change. The program updates all 150 launch facilities and fifteen launch control centers, ensuring the base's arsenal of Minuteman III remain a safe, secure, and effective strategic deterrent. (*341st Missile Wing Public Affairs Office*)

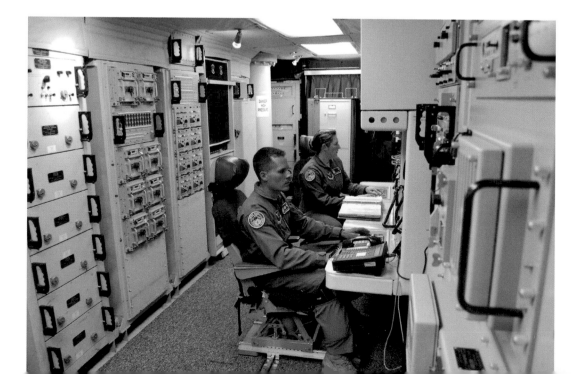

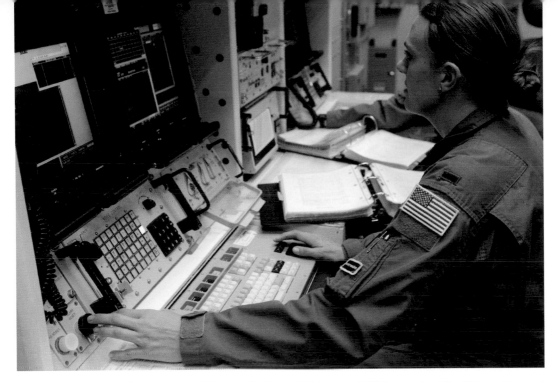

SUBTERRANEAN SENTINELS AT WORK: All fifteen of Malmstrom's LCCs contain a "Rapid Execution and Combat Targeting" (REACT) command and control system. The Air Force developed these consoles for the Peacekeeper Rail Garrison program during the late 1980s. After the cancelation of the Rail Garrison program, the service retrofitted REACT systems inside Minuteman LCCs at Minot, Malmstrom, and F.E. Warren AFBs. During its initial fielding, missileers nicknamed REACT "War by Windows," after the popular computer operating system of the time. The system contains a communications suite to receive emergency action messages from higher headquarters, as well as a weapon system control element to monitor the status of the LCC's ten assigned ICBMs, as well as the squadron's fifty missiles. Below, a missile combat crew member opens the floppy disk drive doors on the SAC Digital Information Network (SACDIN) communications rack. Identified in 2016 by the Government Accountability Office as the "oldest federal IT investment," SACDIN hardware still ran on 8.5-inch floppy diskettes. Today, modern storage devices replaced the floppy diskettes, but the Air Force retained the legacy floppy diskette door façade inside the SACDIN rack. (*341st Missile Wing Public Affairs Office*)

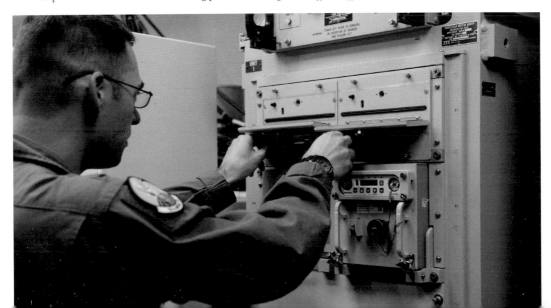

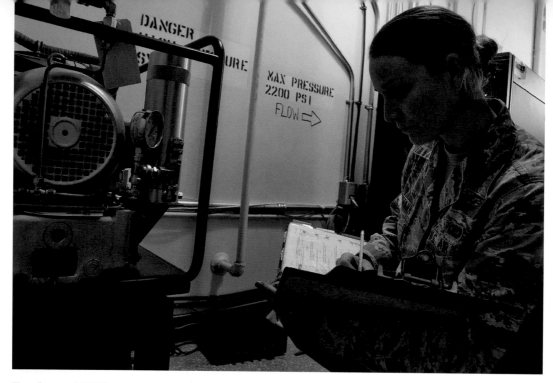

The Other MAF Residents: SSgt Tara Kindermann, 490th Missile Squadron facility manager, reviews a daily checklist for equipment operation. Facility managers act as a "Jack/Jane of all Trades," being a majordomo, repair expert, and liaison with the missile combat crew below ground. FMs conduct daily inspections at their MAFs and take extreme pride in their duty station's appearance and functionality. Below, Chaplain (Capt.) Bill Mesaeh poses for a photo with SSgt Alex Hubbard, a FM in the 10th Missile Squadron during May 2020. Chaplain Mesaeh stayed fifteen nights at fifteen MAFs across Montana to spend time with missile field deployers. (*341st Missile Wing Public Affairs Office*)

Defanging a Minuteman Missile: On June 16, 2014, this payload transporter drove through the gate of the weapons storage area after returning from the missile complex, completing the removal of the last multiple independently targetable re-entry vehicle (MIRV) in the Air Force ICBM inventory. The de-MIRVing process brought the Minuteman force in compliance with the terms of the New Strategic Arms Reduction Treaty (New START), with each missile containing a single re-entry vehicle. Below, a missile convoy travels with a fully armed escort. While this sight is not uncommon on Montana roads, nearby vehicles are warned not to interfere with the convoy's movement. (*341st Missile Wing Public Affairs Office*)

HELO OPERATIONS IN MONTANA: The 40th Helicopter Squadron assists in a convoy movement through the missile complex, providing aerial support and cover. When not assisting security forces, 40 HS crews are often called upon for rescue operations in Montana's wilderness. Below, A UH-1 lands in a snowy field attempting to rescue stranded hikers. (*341st Missile Wing Public Affairs Office*)

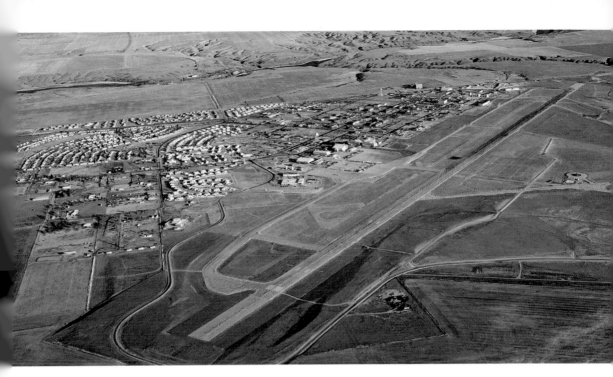

MALMSTROM AFB IN THE NINETIES: An aerial view of the base shows that not much has changed over the decades to Malmstrom's footprint near Great Falls. Below, an image of the main gate shows what it looked like in the 1990s during the operations of the 43d Air Refueling Group alongside the 341st Missile Wing. (*National Archives and Records Administration*)

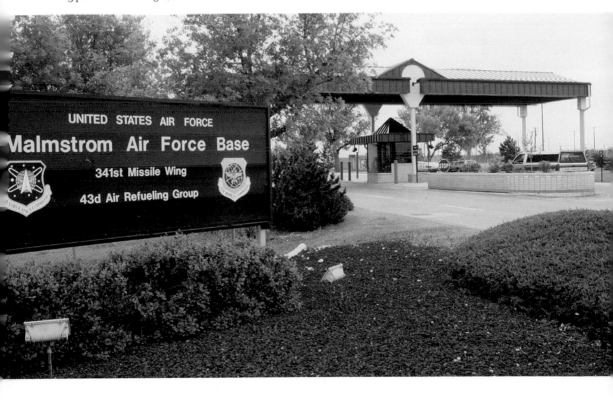

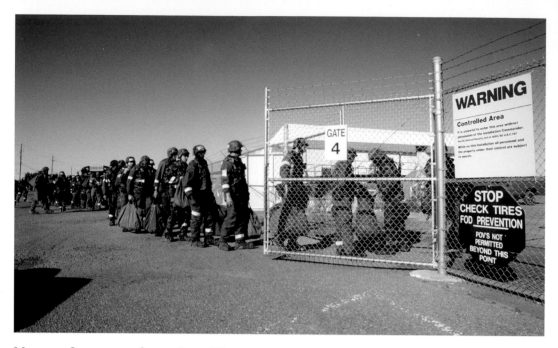

MILITARY OPERATIONS OTHER THAN WAR: During exercise Crisis Reach '95, deployers form a line into the exercise area near Malmstrom's flight line. Below, a C-5 maneuvers near a tent city built close to the base flight line. Exercises such as these prepared Air Force members in becoming a newly mobile force in the 1990s. Global crises were countered with American and United Nations humanitarian operations, ranging from security, food distribution, and peacekeeping. These roles helped define the U.S. military throughout the 1990s. (*National Archives and Records Administration*)

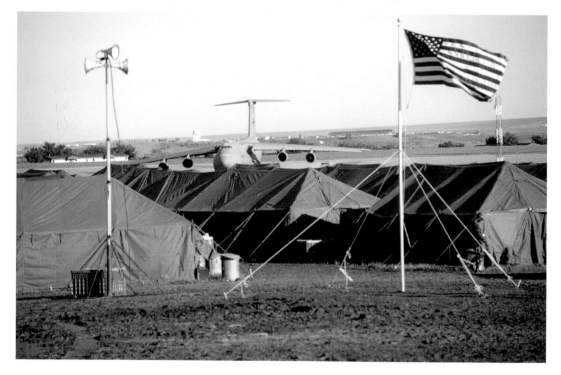

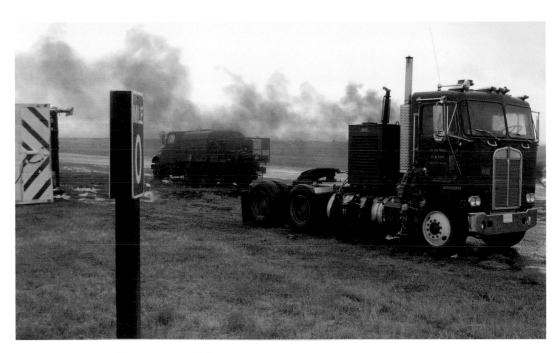

EXERCISE IS GOOD FOR THE MIND AND BODY: A transporter erector (above) is flipped on its side during a nuclear surety inspection event, providing realism to responding crews. Below, a mobile command post vehicle is positioned during a major accident response exercise (MARE) in 1995. Base members get to practice contingency procedures, as well as day-to-day functions during these events. While seemingly excessive in its presentation, these events allow judgment of team performance against Air Force regulations and nuclear surety rules. (*National Archives and Records Administration*)

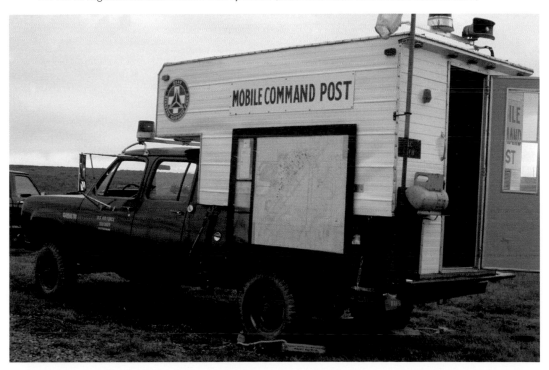

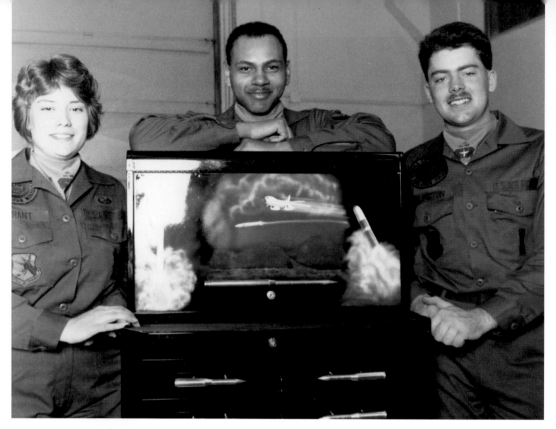

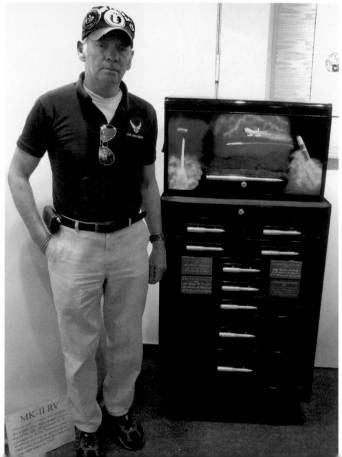

TOOLS FOR LIFE: Above, three 341 SMW Olympic Arena competitors pose next to their toolbox "good luck charm," prior to the 1988 missile crew competition. Master Sergeant Donald Jones (left) crafted the toolbox for the 1986 competition, with a hand-painted mini-mural representing portions of the nuclear triad and specially-made drawer handles shaped like Minuteman missiles. Jones worked on the project in the evenings over a two-week period. In 2014, now-retired Mr. Jones visited the Malmstrom museum and saw the toolbox on display. (*Author's Collection/341st Missile Wing Public Affairs Office*)

MK-II RV

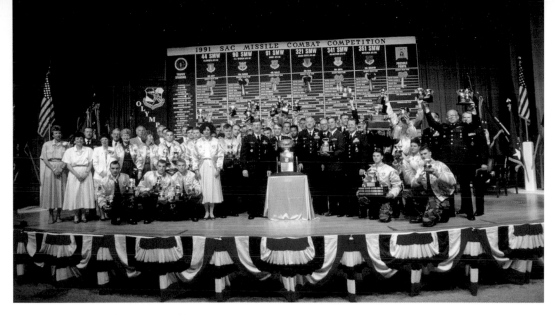

MALMSTROM'S WINNING STREAK: The 341st Strategic Missile Wing celebrates the Blanchard Trophy win at the SAC Missile Combat Competition in April 1991. The competition was the final year using "Strategic Missile Wings" as monikers. The SMWs were renamed to "Missile Wings" (dropping the "strategic") in September 1991. Below, Malmstrom airmen take home the Blanchard during the next iteration of the competition, Air Force Space Command's Guardian Challenge. The 341st mascot "Grizz" (2Lt. Chris Dauer), 1Lt. Drew Woodbury (center left), SrA Sam Jennings (behind trophy), and A1C Christopher Stephens (far right) escort the trophy from a C-17 transport onto a bus at the Great Falls International Airport after completion of the 2006 Guardian Challenge competition. (*Author's Personal Collection/341st Missile Wing Public Affairs Office*)

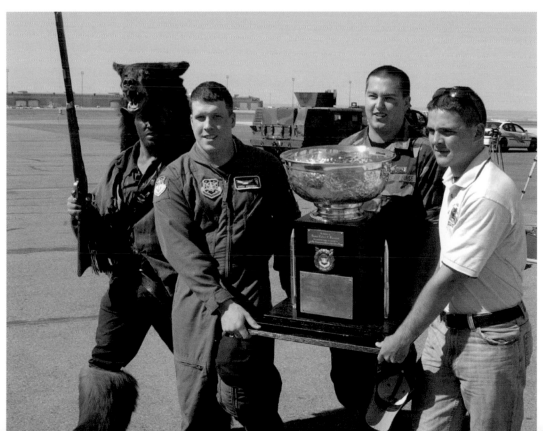

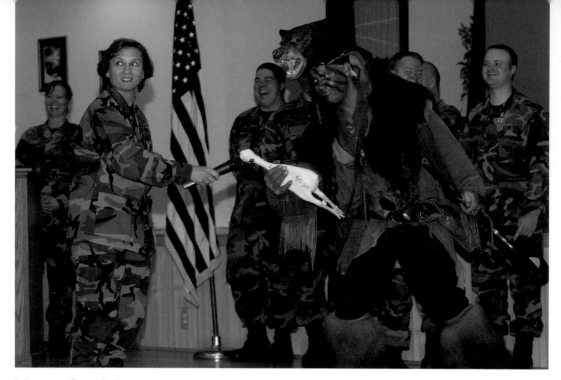

MASCOTS GONE WILD: Col. Sandra Finan, 341 MW commander, introduces "Grizz" the wing mascot during a valiant return after the wing's Blanchard win during the 2006 Guardian Challenge competition. To increase team cohesion and morale, each Minuteman and Titan missile wing created a mascot representing their base's culture during the missile combat crew competition. As times and cultural values change, so do the mascots. The High Plains Warrior represented the wing competitions throughout the late 1990s to early 2000s. Below, SSgt Kevin Barber, 341st Logistics Support Squadron, leads the Malmstrom team as the High Plains Warrior on the flight line at Vandenberg AFB, California. (*341st Missile Wing Public Affairs Office/341st Missile Wing History Office*)

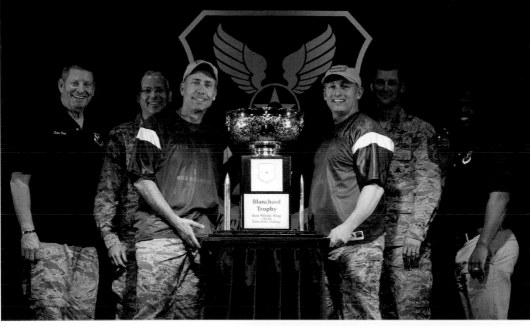

NEXT-GENERATION COMPETITION AND A FAMILIAR TROPHY.

Col. John T. Wilcox, 341st Missile Wing commander (above center left), accepts the Blanchard Perpetual Trophy at the 2015 Global Strike Challenge trophy presentation on October 21, 2015. Global Strike Challenge is the nation's premier bomber, ICBM, helicopter operations, and security forces competition with units from Air Force Global Strike Command, Air Combat Command, Air Force Reserve Command, and the Air National Guard. The competition is an amalgamation of the missile combat competition, bombing competition, and a number of other events held over the decades. While 2015 was the 341 MW's first Global Strike Challenge win, Malmstrom members held an impressive win streak in years before (and after). Right, the Blanchard Perpetual Trophy during its initial awarding in 1967 had a representative Minuteman missile alongside a LGM-25C Titan II missile. (*341st Missile Wing Public Affairs Office*)

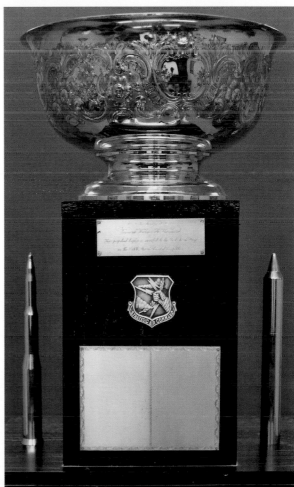

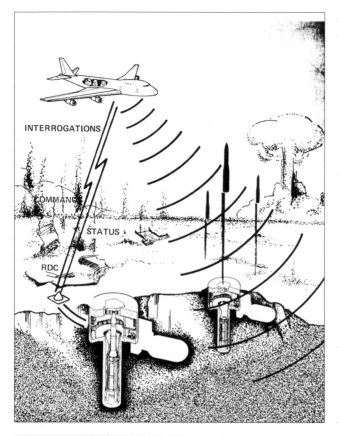

INTERROGATIONS

COMMAND

STATUS

RDC

VOICES FROM BEYOND THE GRAVE: The airborne launch control system (ALCS) has the capability to launch intercontinental ballistic missiles from any launch facility in the nuclear triad. The diagram (left) illustrates the ability of the ALCS aircraft to transmit interrogations and receive status from LFs, as well as launch commands. While the setup aboard the aircraft looks different, the ALCS mirrors the capabilities of the underground LCCs to transmit launch commands to the missile fields. Below, two EC-135s engage in aerial refueling. EC-135s maintained their air-refueling capability in conjunction with the Looking Glass/ALCS mission. The 4th Airborne Command and Control Squadron, based at Ellsworth AFB, South Dakota, provided coverage to Malmstrom's missile fields during the Cold War decades. (*National Archives and Records Administration*)

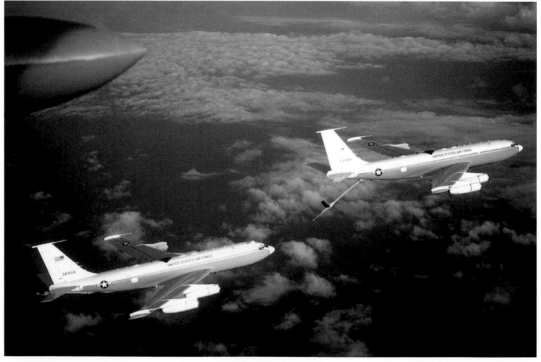

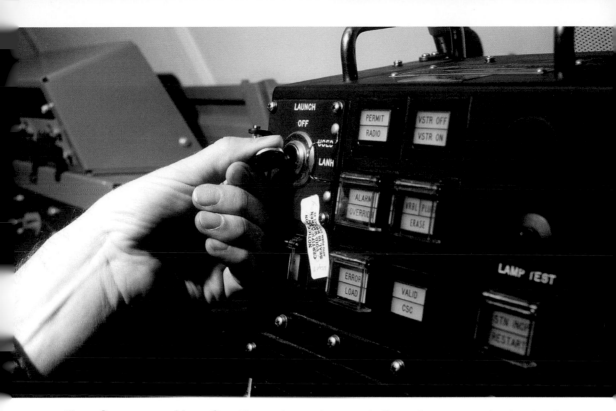

TAKE CHARGE AND MOVE OUT: The top image shows a missile combat crew member turning the launch key aboard an EC-135 equipped with the Airborne Launch Control Center suite. The 341st Missile Wing crews practice this capability twice a month with Giant Ball radio tests. During Giant Ball tests, Launch Facility Radio Test sequences are sent to each LF within a missile complex, as well as a UHF voice communication poll sent to each of the LCCs. The joint Air Force and Navy crew of an E-6B Mercury aircraft (bottom), stationed with the 625th Strategic Operations Squadron based out of Offutt Air Force Base, Nebraska, pose for a picture on the tarmac of Great Falls International Airport on April 5, 2016. Also based on the Boeing 707 airframe, the E-6B aircraft replaced the EC-135 ALCS mission in 1998 and incorporated capabilities to communicate with Navy strategic nuclear submarines. The E-6B serves as a last line of defense and crucial redundancy for the nation's nuclear command and control system. (*National Archives and Records Administration/341st Missile Wing Public Affairs Office*)

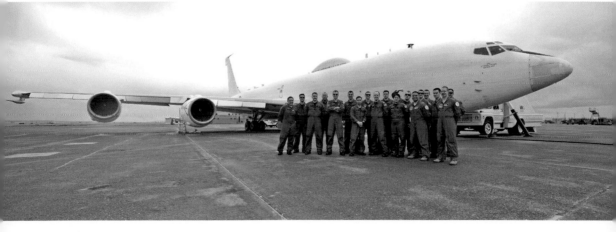

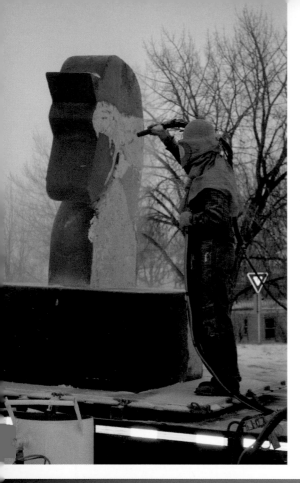

Restoring RED HORSE Pride

(AND PAINT): Mr. Phil Lane (left), a local business owner, sandblasts the paint off the 819th RED HORSE Squadron (RHS) statue. The statue was originally poured and erected in the spring of 1982 at a remote RED HORSE compound in Egypt. After nearly thirteen years in the Middle East, Scott Hansen, one of the creators of the statue (re)discovered it and brought the statue "home" to the United States. After a few years at Hurlburt Field (FL), the statue came to Malmstrom AFB after the reactivation of the 819 RHS. The restoration and repair process took two full days, stripping layers of paint and reinforcing the concrete. The final step was to paint the horse and statue base red and black, respectively. Below, SSgts Johnathon Stone and Daniel Berner hammer down a stake for a cement pad at Forward Operating Base Dwyer, in Afghanistan. SSgts Stone and Berner deployed from the 819th Red Horse Squadron at Malmstrom, AFB. The acronym RED HORSE stands for "Rapid Engineer Deployable Heavy Operational Repair Squadron Engineers." These units provide a combat engineering capability for the Air Force that is similar to the U.S. Navy Seabees and U.S. Army heavy-construction engineers.
(*341st Missile Wing Public Affairs Office*)

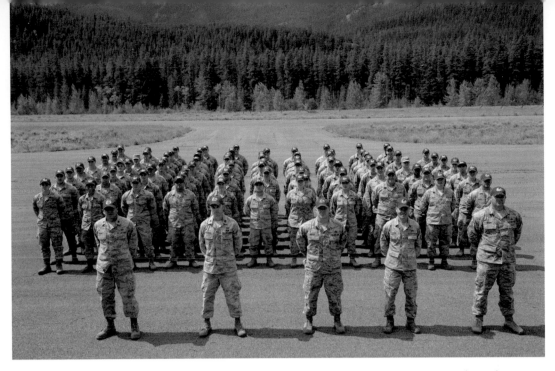

EXPEDITIONARY AIRPOWER IN ACTION: The 819th RED HORSE Squadron airmen (above) stand in formation at the Benchmark Airport near Augusta, Montana on July 27, 2017. Known for their rapid construction capabilities, the 819th members flew to Augusta aboard a 120th Airlift Wing (Montana Air National Guard) C-130 Hercules to practice a bare base build-up during a short-notice deployment. RED HORSE's major wartime responsibility is providing a highly mobile, rapidly deployable, self-sufficient civil engineering response force to perform heavy damage repair to austere locations. RED HORSE members have often served in active combat zones, under constant threat of attack. Below, SSgt Joseph Dickison, 819th RED HORSE Squadron heating, ventilation, and air conditioning (HVAC) technician (below right) is awarded a Purple Heart medal during a ceremony inside the Airfields Hangar on December 9, 2016. SSgt Dickison was awarded the Purple Heart for combat wounds received in Afghanistan during July 2009. (*341st Missile Wing Public Affairs Office*)

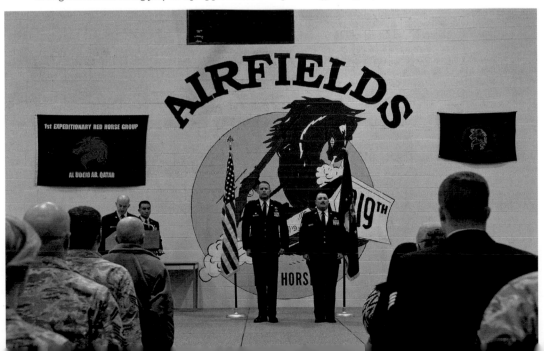

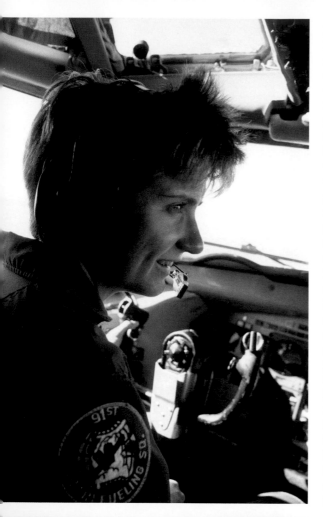

POLITICAL BATTLES FOUGHT BY MALMSTROM AIRCREWS: On January 5, 1988, Malmstrom gained an aerial refueling organization, the 301st Air Refueling Wing (ARW), the first since the 4061st ARW inactivated nearly three decades earlier. The 301st was deployed to the Persian Gulf in support of Operation Desert Shield/Desert Storm in mid-1990. Capt. Bonnie Van Dyke (left), a KC-135 Stratotanker aircraft pilot with the 91st Aerial Refueling Squadron, prepares her aircraft for departure on a flight to Saudi Arabia on August 18, 1990. The 301st ARW flew 443 combat sorties, refueling over 900 coalition aircraft by transferring approximately 33.5 million pounds of fuel. The return of the aerial-refueling mission did not last long, however. In 1995, the Base Realignment and Closure (BRAC) Committee recommended removing the aerial refueling mission from Malmstrom and shifting its assets to MacDill AFB, Florida. On March 31, 1995, retired Col. Lynn Guenther (below center) presented arguments for keeping the 43rd Air Refueling Group and their twelve remaining KC-135 tankers at Malmstrom. Seated around him at the table from left to right are Montana's Governor Marc Racicot, Senators Max Baucus and Conrad Burns, Congressman Pat Williams, and Commissioners Kling, Davis, and Cox. (*National Archives and Records Administration*)

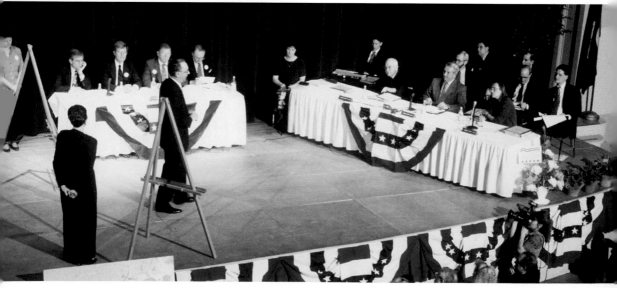

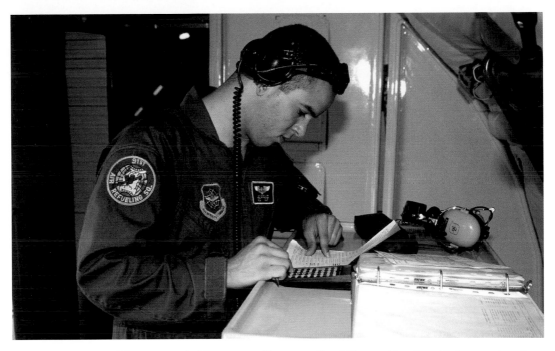

FAREWELL TO MALMSTROM'S MISSION OF "PASSING GAS:" The gambit to keep Malmstrom's tankers during the BRAC proceedings ultimately failed. The inactivation of the 43rd Air Refueling Group and transfer of Malmstrom's twelve KC-135R tankers to MacDill AFB, Florida ended all permanent fixed-wing flight operations at Malmstrom AFB. Above, A1C Luis Gonzalez, 91st ARS boom operator, computes the weight and ballast of his KC-135R aircraft (s/n 62-3533) before its final departure from Malmstrom AFB on September 30, 1996. Once arriving at MacDill, the 91st Air Refueling Squadron and its twelve tankers became part of the 6th Air Refueling Wing. Below, KC-135R s/n 62-3533 prepares for takeoff, with its "43 ARG" and "Malmstrom AFB" markings proudly displayed on its final flight from the base. While originally built as a KC-135A model, 62-3533 received an engine retrofit with CFM56 high-bypass turbofan engines, offering a 100 percent increase of thrust (to 22,500 lbf or 100 kN) from the original J57 engines. The resultant savings in cost and fuel efficiency, while carrying more fuel, allowed the 1960s-era tanker to fly on into the twenty-first century. (*National Archives and Records Administration*)

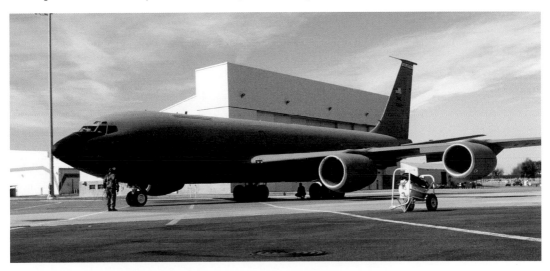

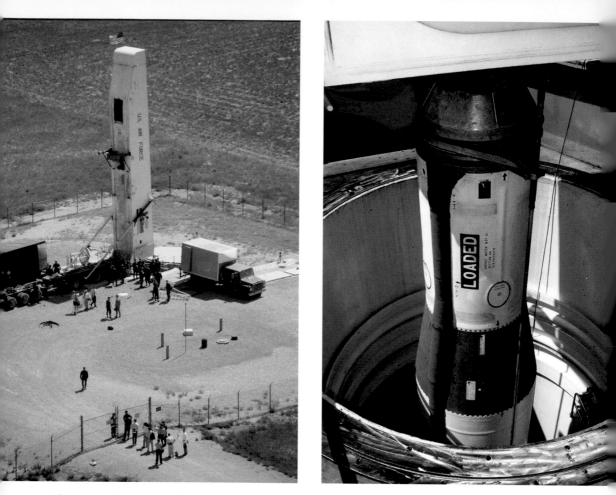

A SENTINEL LEAVES ITS POST: News reporters clamor around the topside of Kilo-11 (K-11) as the 341st Missile Maintenance Squadron pulls the final LGM-30F Minuteman II from the launch tube on August 10, 1995. Changes in the global situation at the end of the Cold War had U.S. war planners re-examine nuclear deterrent objectives in the face of massive disarmament. By examining desired nuclear capabilities at the end of the Cold War, President George H. W. Bush directed the Air Force to remove LGM-30F Minuteman II forces from nuclear alert on September 28, 1991. The removal of the Minuteman II from the strategic inventory allowed the Air Force to "recycle" some silos at Malmstrom AFB with the newer missile, the LGM-30G Minuteman III. Other Minuteman II missile complexes in South Dakota and Missouri were completely deactivated, and their silos were imploded. The day-to-day coloring of a Minuteman II is shown (above right) as the missile at K-11 is lifted out of the launch tube into a transporter erector. Unlike the "gate guard" missiles displaying a pristine white paint job, operational missiles are a mixture of white and green. The green coloring is a fungicide that prevents microbial growth on the missile's surface. Melting Montana snow often found its way down into the launch tube, collecting at the bottom and supporting the growth of microorganisms. The stenciled "LOADED" on the second stage identifies a fully capable rocket motor, not a training or dummy device. (*National Archives and Records Administration*)

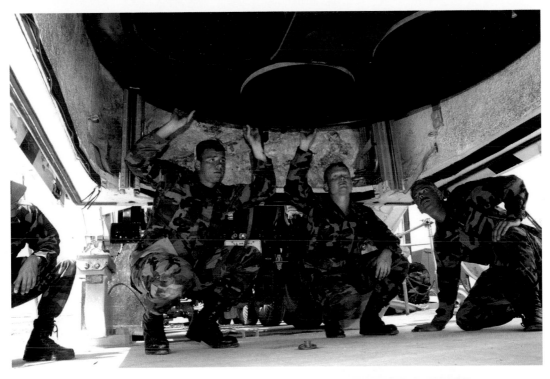

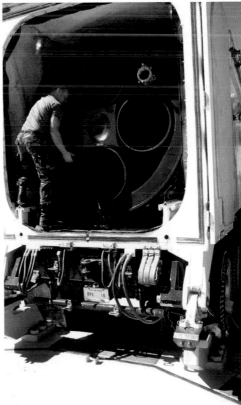

RIDING INTO THE SUNSET: SSgt Gordon Gibney of the 341st Logistics Support Squadron (above, far right) inspects the thrust vector control nozzle exit cones of a recently pulled LGM-30F Minuteman II, while SrA Paul Lee (above, center left), SrA Brant Dodd (above, center right), and Technical Sergeant David Voran look on (above, far left). This missile was the last Minuteman II ICBM removed from Malmstrom's missile complex. Unlike other units that operated the Minuteman II, the 341st Missile Wing did not inactivate after the missile type was removed from the inventory; the Air Force just replaced the empty LFs with "newer" LGM-30G Minuteman III ICBMs. Right, SrA Brant Dodd stands inside the rear of the transporter erector while he inspects the thrust vector control nozzles after the installation of a nozzle control limiter (the red square in the center). The limiter is a spacer, preventing the four nozzles from hitting each other during transport. Impact to any Minuteman down-stages can cause damage to the rocket motors or the solid fuel material inside. Extreme care is taken to transport the missiles to and from the LFs, and non-destructive inspection (NDI) techniques are used to inspect the downstages at the missile support base. (*National Archives and Records Administration*)

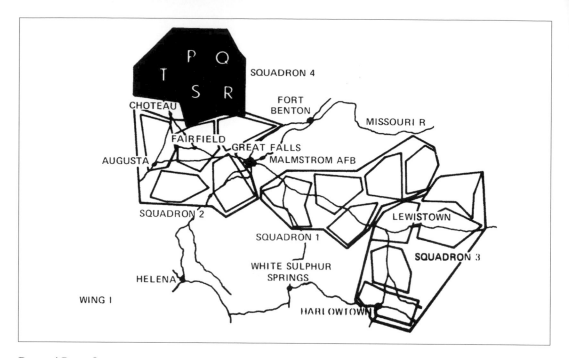

DEUCE! PART ONE: The Air Force named and numbered its Sylvanian-built WS-133B Minuteman facilities in a unique way. Flight names were alphabetical, as seen in the image above, just like the rest of the force. However, since the 564th (S)MS was the last squadron added to the 341 SMW, it received allocation for the letters P(apa), Q(uebec), R(omeo), S(ierra), and T(ango). MAFs were all designated 0 (zero), such as Papa-Zero (P-0). LFs were numbered in groups of ten, but in a sequential manner for the entire squadron. For example, Papa Flight had LFs P-1 through P-10; Quebec Flight had Q-11 to Q-20; Romeo Flight contained R-21 to R-30; Sierra Flight was numbered S-31 to S-40; and the Tango Flight followed up the rest with T-41 to T-50. Below, a missile combat crew member reads a checklist while on alert. The command and control of Minuteman missiles relied on communications links, such as the HICS network, microwave links, and even the telephone attached to the console. (*National Archives and Records Administration*)

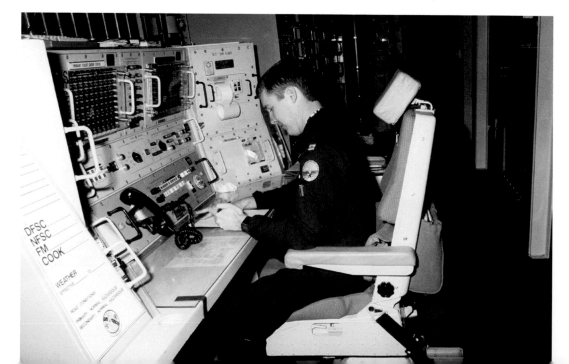

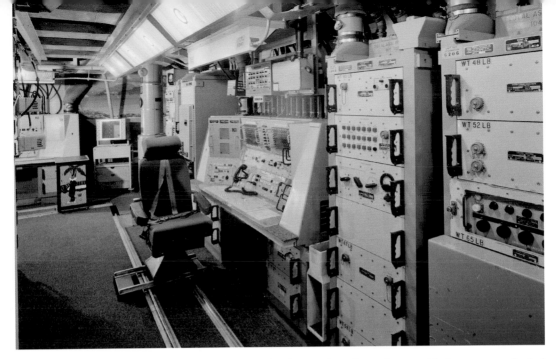

DEUCE! PART TWO: The WS-133B command and control configuration provided an unprecedented amount of space inside the launch control center. In the image above, a crew member chair is positioned in front of the status control console, which allows the deputy missile combat crew commander to monitor the status of the flight's ten ICBMs and communicate with the squadron's other LCCs. After the conversion to the REACT configuration, crew members could walk laps around the LCC (approximately eighty-three laps equaled 1 mile). Below, a crew member adjusts the safety belt on his seat. These seats ride on rails to allow access to the most important equipment racks — communication, alarm/monitor sets, and of course, the enable and launch switches. During emergency war order configuration, crews were required to "lock-in" their chairs, to prevent unnecessary movement and to prevent serious injury during a nearby nuclear detonation (NUDET). During normal alert periods, crews could adjust the seats for their own comfort. (*National Archives and Records Administration*)

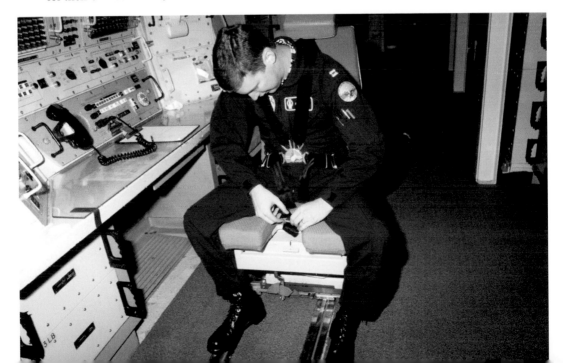

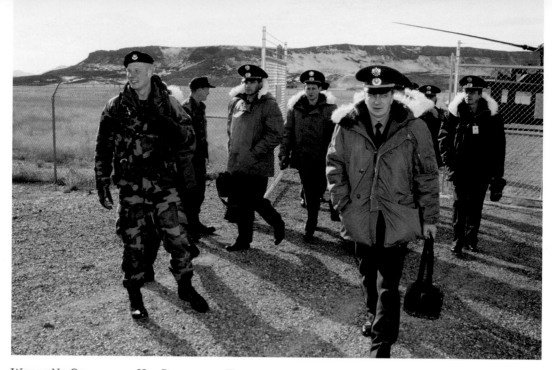

WHERE NO COMMUNIST HAS PREVIOUSLY TREAD: Above, USAF Security Forces A1C Thomas Lockwood (left) escorts visiting Russian Strategic Rocket Forces delegates as they enter onto LF India-06 (I-06) near Cascade, Montana, on October 31, 1996. While on-site at I-06, the Russian visitors entered the LF to see the Minuteman III ICBM in the launch tube. Visits such as these were allowed by the Strategic Arms Reduction Treaty (START), signed on July 31, 1991. Below, U.S. Army linguist SSGT Michael Arrowsmith (second from left) translates as SrA Brad Domingo, a missile maintenance team training instructor, describes the security measures involved in preventing unauthorized access to a Minuteman III missile to the Russian SRF visitors. The group is standing next to the LF's opened primary access shaft, containing a ladder to climb down into the launcher equipment room. The heavy steel construction of the access portal and hatch is meant to prevent unauthorized access into the LF. (*National Archives and Records Administration*)

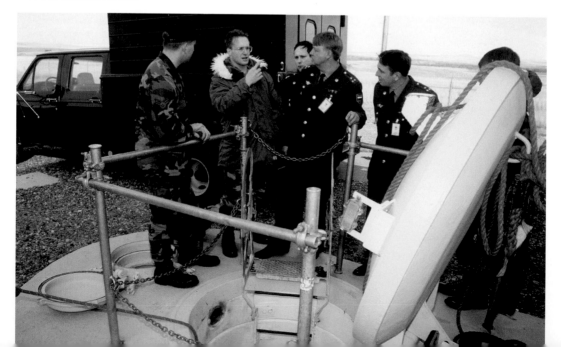

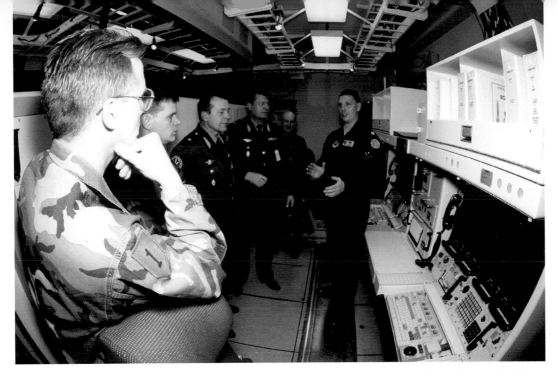

ECHOES OF THE LEND-LEASE PARTNERSHIP: Above, Russian Strategic Rocket Forces General Maj. Yuriy Yegen'yevich Kononov (Missile Division Commander) and General Maj. Rudol'lf Romanovich Shmykov (SRF Directorate Chief), tour Malmstrom AFB's missile procedures trainer (MPT) in November 1996. Capt. Tim Glyn (center right) from the 341st Operations Training Flight briefs how crew members stay proficient through simulations inside the MPT, while two U.S. Army linguists, SSgt Michael Arrowsmith and SFC Glenn Hervi (far left) provide translations. At the back of the room is Col. Wayne DeReu, a former 341st Missile Wing vice commander, representing 20th Air Force Safety during the exchange visit. Below, a MiG-17 (left) and MiG-15 (right) flank a FJ-4 Fury jet during an aerial demonstration over Malmstrom AFB on July 13, 2019. The MiG Fury Fighters performed acrobatics and dogfighting for the airshow crowd. The presence of former Soviet hardware seemed apropos for those familiar with Malmstrom's Lend-Lease history. (*National Archives and Records Administration/341st Public Affairs Office*)

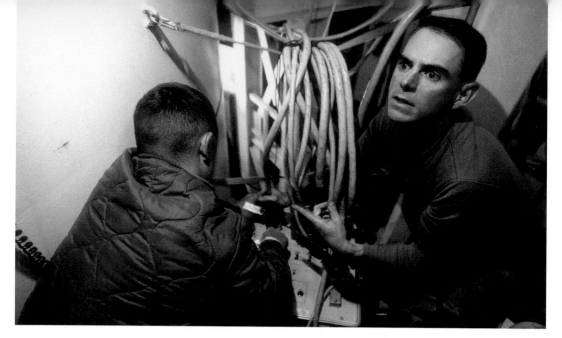

MEANWHILE, INSIDE THE LAUNCH FACILITY: A1C Tyler Lee (above right) and an unidentified airman (above left), both from the 341st Missile Maintenance Squadron, remove yellow electronic test cables inside of a LF. Designed in the 1960s, the LGM-30G Minuteman III weapon system depends heavily on microelectronic integrated circuits to perform a myriad of monitoring and test functions throughout the missile and ground equipment. When new equipment is installed, or problems arise, maintainers must troubleshoot and test the equipment with portable gear trucked in from the missile support base. Then the troubleshooting "fun" begins. The view inside of LF Golf-11 (G-11), below, shows missile maintenance technicians SrA Daniel Horn (below left) and SrA Joshua Palmanteer (below right) pull the aft shroud ring down around the titanium shroud assembly of a Minuteman III. The shroud protects the re-entry vehicles underneath as the missile rockets toward its destination. At a predetermined time, a rocket motor inside the tip pulls the shroud away from the rest of the post-boost vehicle. Titanium has a high tensile strength (even at high temperatures), is lightweight, and possesses extraordinary corrosion resistance and an ability to withstand extreme temperatures—all desirable characteristics for the pointy end of an ICBM. (*National Archives and Records Administration*)

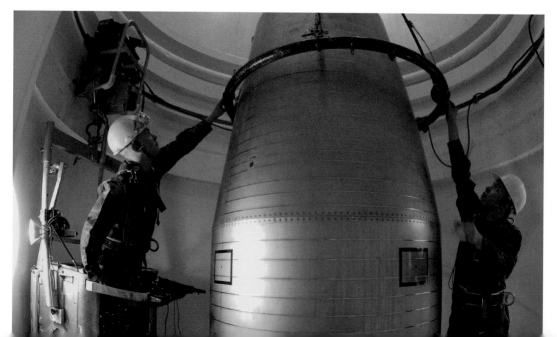

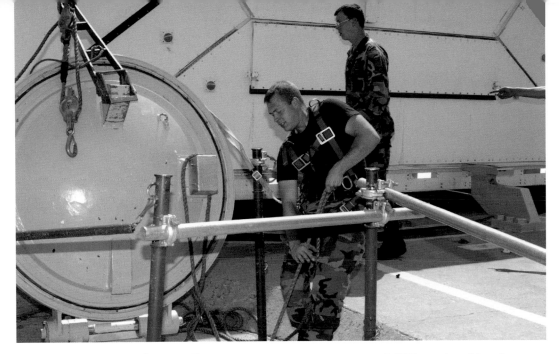

MAINTENANCE IN SUN AND SNOW: Two missile maintenance team (MMT) members (above) prepare to enter the LF via the personnel access system tunnel and ladder. The large white metal disk to the left is the primary door into the access tunnel. In the background, a payload transporter semitrailer sits above the launcher closure in preparation for maintenance inside the LF. On site work at the LF is strenuous, with each team having to lower their tools through the access tunnel and lifting them topside again when maintenance is complete. Aside from the (gravity) fall hazards present, many other hazards exist at the LF even in the best of weather. During wintertime, however, the same maintenance must be accomplished in freezing temperatures with ice and snow aside, atop, and sometimes inside the LF, as seen below. With over 200 LFs in the Malmstrom missile complex prior to 2008's inactivation of the 564th Missile Squadron, missile maintenance troops were constantly busy. The inactivation of the 564th's fifty LFs lessened the maintenance load slightly due to the retirement of the WS-133B "Deuce" weapon system. However, 341st Missile Wing maintainers continue to remain ready twenty-four hours a day to travel out to the missile complex. (*341st Missile Wing Public Affairs Office*)

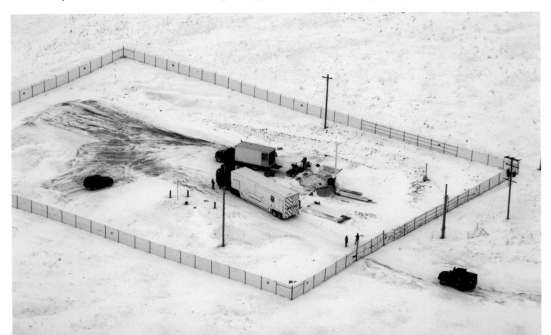

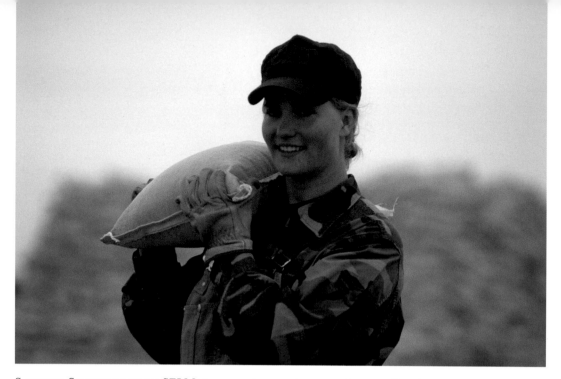

SANDBAG SMASHING WITH SELM: A young airman, above, carries a sandbag in preparation for a simulated electronic launch, Minuteman (SELM) operation out at a LF. SELM tests allow for end-to-end operation of the entire Minuteman weapon system. Key launch components are disabled (and simulated) to allow crew members to run through their checklists from initial message receipt to turning launch keys. At the LF, one of the end-to-end tests performed is the emergency war order (EWO) opening the launcher closure. During wartime, the launcher closure ballistic actuators would quickly move the door away from the opening of the launch tube to allow the Minuteman sortie to take flight. Since the purpose of SELM is to test and not demolish the LF security fence topside, a wall of sandbags (below) is stacked nearby to absorb the force of the launcher closure's rapid opening, as seen below. SELM tests provide verifiable reliability that the Minuteman weapon system will work as intended in case it is ever needed. (*National Archives and Records Administration*)

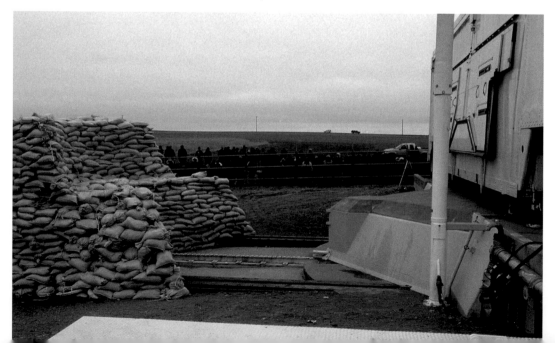

A Balancing Act:

A1C Jason Gill of the 341st Missile Maintenance Squadron (right) stands in a work cage while performing maintenance on the inside of the launch tube. Minute details can be seen, such as the many rivet-like small circular connectors between the missile's stages. These high-torque ("coin-slot") connectors hold the stages together. The term "coin-slot" bit refers to the use of a common penny to loosen or tighten connections of this type on other aerospace equipment. Only authorized tools and appropriate technical data are used during maintenance at the LF or on a missile. Atop the LF, an unidentified senior airman security forces member (below) radios his observations during a security sweep. When required, Air Force security forces take position on or near the launch facility grounds to monitor any threats in the area. If the problem persists, a two-person camper alert team will remain at the LF until the threat is neutralized or the problem is resolved. (*National Archives and Records Administration*)

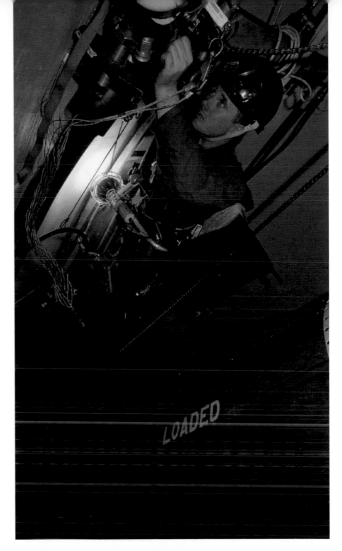

FULL MISSILE FIELD SUPPORT, BAR NONE: The Malmstrom Honor Guard (above) fold the American flag during the Police Week retreat ceremony held on May 15, 2009, while members of the 341st Security Forces Group and 341st Missile Wing leadership stand at attention. National Police Week was established by a joint resolution of Congress in 1962, to pay special recognition to law enforcement members who have lost their lives in the line of duty. Below, celebrity chef Robert Irvine shows missile field chefs how to use fresh ingredients to enhance their dishes for the personnel out in the field during a visit on September 7, 2017. Chefs are stationed out at the MAFs for short duration tours to prepare meals for security forces, missileers, and maintainers. While menu choices such as hamburgers and tater tots may seem to echo a "roadside diner" mentality, many healthy food choices are also available to reinforce the service's mission of keeping its personnel fit and healthy. Chefs often take part in competitions with their civilian counterparts around the country and use engagements such as Irvine's visit to help missile field personnel make healthier meal choices. (*341st Missile Wing Public Affairs Office*)

BUILDING COMMUNITY: Above, Malmstrom volunteers collect, sort, and distribute over 1,000 cookies during the Annual Cookie Express drive on December 15, 2016. The goal of the drive is to collect sweet treats for dorm residents and twenty-four-hour work centers. Dorm residents are junior enlisted military members (approximately eighteen–twenty-two years old) who may be alone during the holiday season. Events like these show appreciation for the junior enlisted from the base and local community members. Visits, such as the B 52 crew members visiting Malmstrom (below), help reinforce community with the warfighting arms of AFGSC. These B-52 aircrew members from the 2nd Bomb Wing were part of the bomber–missile exchange course, providing mid-level AFGSC leaders with a broad scope of understanding of tactics, techniques, and procedures applicable across both B-52 and Minuteman weapon systems. (*341st Missile Wing Public Affairs Office*)

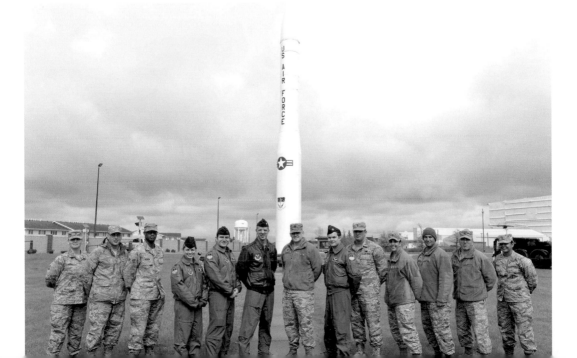

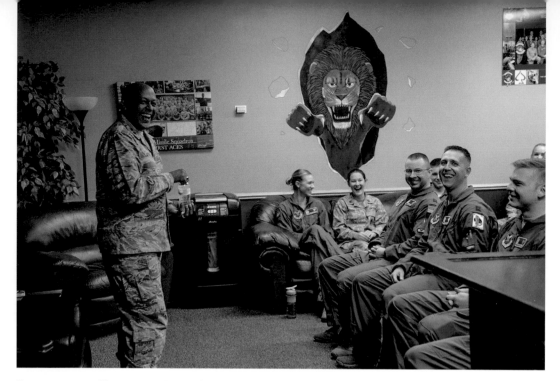

DISTINGUISHED VISITORS TO WING ONE: On October 11, 2017, Maj.-Gen. Anthony Cotton (top), 20th Air Force commander, met with missileers in the 10th Missile Squadron Heritage Room. He met with members of the missile and security forces squadrons during his visit to Malmstrom AFB. Below, Commander of U.S. Strategic Command, Gen. John Hyten (right rear), his wife Laura (center), and Command Chief Master Sgt. (CMSgt) Patrick McMahon (right front) speak with Col. David Miller, commander of the 341st Maintenance Group, and SrA Richard Straniere, 341st Maintenance Group maintainer, while touring a payload transporter on January 16, 2018. The Hytens and CMSgt McMahon toured the base facilities—to include a missile alert facility and weapons storage area—and met with airmen and their families to discuss USSTRATCOM's deterrence mission. (*341st Missile Wing Public Affairs Office*)

PERSONALITIES OF MALMSTROM: Above, CMSgt Eryn McElroy, 341st Missile Wing command chief (above), throws two "thumbs up" with a smile outside of wing headquarters on October 4, 2018. Below, the Spratt twins—A1C Leland (left) and A1C Lemuel Spratt (right)—pose for a portrait in front of a security forces mural. The Spratt twins have been inseparable, spending all but a few days of their lives together, even after joining the Air Force. Both Spratts are members of the 341st Missile Security Forces Squadron, performing security functions inside Malmstrom's sprawling missile complex. (*341st Missile Wing Public Affairs Office*)

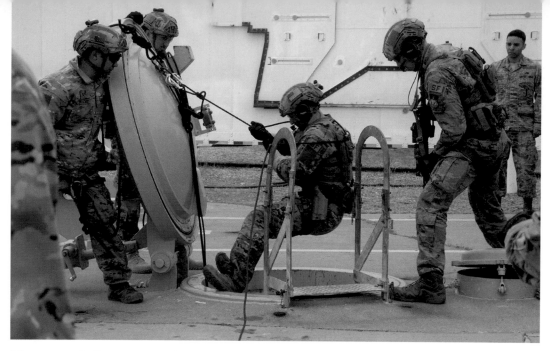

MALMSTROM'S SENTINELS IN ACTION: Above, members of the 341st Security Support Squadron tactical response force rappel down an access tunnel during a recapture exercise on May 6, 2019. The LF recapture was performed for civic leaders as a demonstration of the different tasks Malmstrom AFB airman perform, as well as the resources required to protect the base's unique assets. Below, Airman Kaiulani Vila and SSgt Marco Castillo, 341st Missile Security Forces Squadron, walk the fence perimeter surrounding Alpha-01 MAF on August 28, 2017. Sentries patrol the MAF perimeter to ensure the fence is secure and all warning signs are visible. Anecdotes from other missile bases tell stories of members of the public, usually locals, wandering onto MAF property during snowstorms or inclement weather. The nondescript MAF exterior is often mistaken for a "little house on the prairie," albeit surrounded by a fence and barbed wire. (*341st Missile Wing Public Affairs Office*)

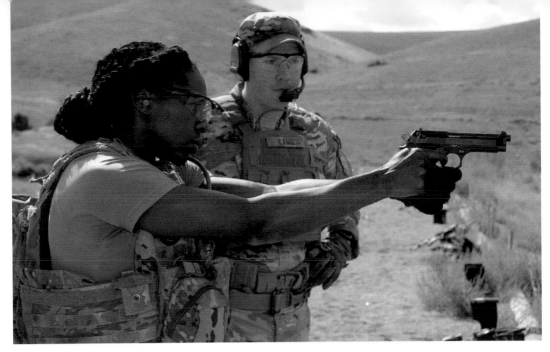

MALMSTROM DEFENDERS HIT CENTER MASS: Above, SSgt William Lamb, 341st Security Forces Group tactical response force member, instructs SrA Rosa Young, 891st Missile Security Forces Squadron (Minot AFB) member, during training exercises at Fort Harrison (MT) for the 2018 Defender Challenge competition. Defender Challenge began in 1952 as a marksmanship contest and evolved to an Olympics-style series of events in 1981 continuing until 2003. Defenders test their expertise in combat endurance, combat agility, weapons testing, and a military working dog competition to earn the Defender Challenge title. Below, A1C Victoria Kelly, 741st Missile Security Forces Squadron flight security controller, fires an M-4 carbine rifle at Fort Harrison's rifle range. A1C Kelly was part of Malmstrom AFB's Global Strike Challenge winning team, hand-selected selected to represent AFGSC at Defender Challenge 2020. The global COVID-19 pandemic forced organizers to postpone the 2020 competition until the following year. (*341st Missile Wing Public Affairs Office*)

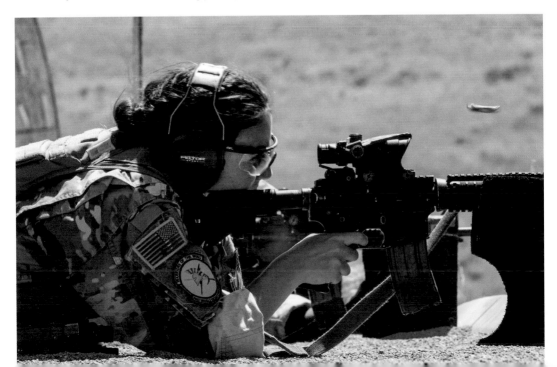

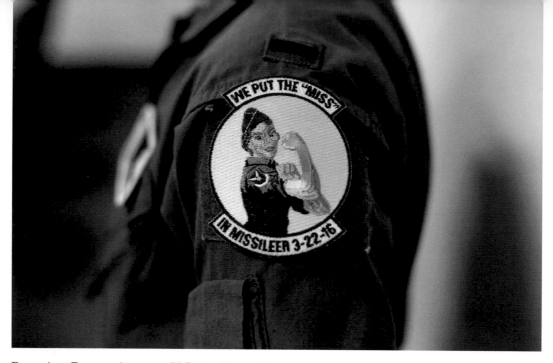

FIRST ALL-FEMALE ALERT IN U.S. AIR FORCE HISTORY: The first all-female alert across AFGSC took place on March 22, 2016, with ninety female missileers on alert in North Dakota, Wyoming, and Montana. Additionally, AFGSC B-52s at Minot AFB (ND) and Barksdale AFB (LA) fielded all-female aircrews. In recognition of the event, participants created a commemorative patch that echoed World War II's "Rosie the Riveter" poster. While the iconic Rosie poster portrayed how women were vital to the war effort on the home front, women do not take a backseat in this event, stating, "We put the 'Miss' in Missileer." Below, five missileers pose after finishing a training session inside of the MPT on March 21, 2016. From left to right: 1Lt. Jennifer Bishop, 2Lt. Alexandra Rea, Capt. Ebony Godfrey, Lt.-Col. Kristen Nemish, and 1Lt. Elizabeth Guidara. Missileers perform extensive training in the MPT to ensure their ability to quickly respond to situations in the missile complex and provide accurate input of essential data to the Minuteman weapon system. (*341st Missile Wing Public Affairs Office*)

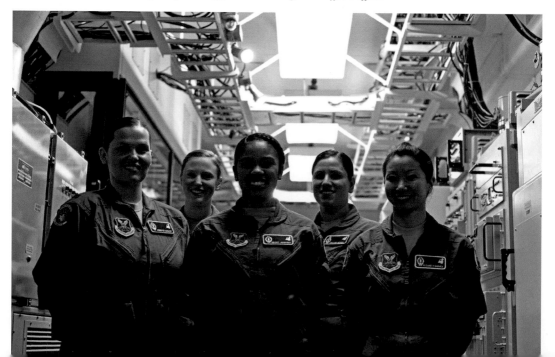

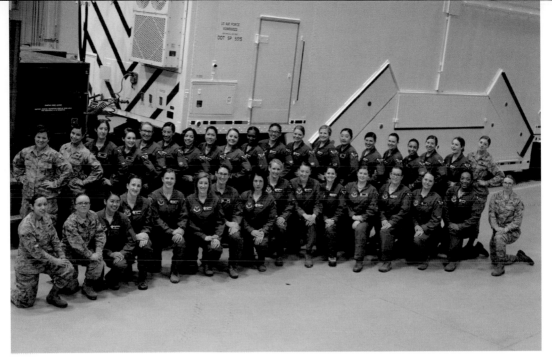

2019 AFGSC ALL-FEMALE ALERT: On March 7, 2019, members of Malmstrom's all-female alert crew posed for a group photo in front of a payload transporter van. In coordination with Women's History Month, AFGSC dispatches all-female alert teams to the missile field on International Women's Day. The women in the photograph represent operators, maintainers, support, and back-shop personnel who directly support the mission every day. The patch for AFGSC's March 2019 all-women alert includes symbolism for each missile wing taken from comic book heroines: Malmstrom's (Wing I) symbol is from Wonder Woman; Captain Marvel's star-emblem represents Minot (Wing III); and the iconic super shield of Supergirl fame represents F.E. Warren (Wing V). (*341st Missile Wing Public Affairs Office*)

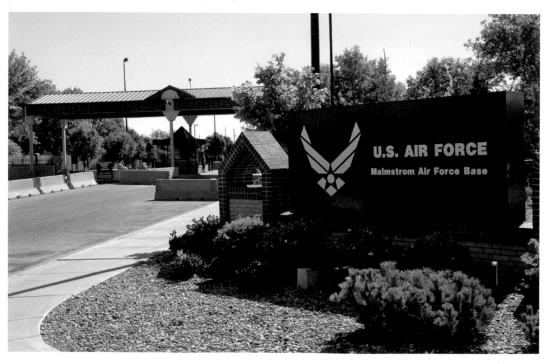

PROUD LEGACY: A sign proclaiming "Welcome to Blanchard Trophy Country" shows the years the 341st Missile Wing earned the title "Best Missile Wing" during the Missile Combat Competition. Since this photo was taken, Malmstrom earned the prestigious honor of the first-ever "three-peat" Blanchard recipients, earning the Blanchard in 2015, 2017, and 2019. Malmstrom's 2nd Avenue gate shows the modified "Hap Arnold" wings introduced by the Air Force in 2000. The service states the new symbol's modern design represents the Air Force's present and future leading-edge capabilities defending the United States. (*341st Missile Wing Public Affairs Office*)

MALMSTROM AIR AND SPACE MUSEUM

The Malmstrom Museum displays photographs, mementos, equipment, and regalia that represent all aspects of life at the Montana air base, from its inception in the early 1940s to the present day. Since the base's first mission was aircrew training for World War II, one of the museum displays shows what B-17 waist gunners wore during combat missions. The green bottle provided breathing oxygen to the gunners inside the unpressurized aircraft. Crews wore a yellow personal floatation device—"Mae West"—since missions had a fair amount of time over water. Incidentally, the life jacket received its nickname due to its shape after being inflated—Ms. Mary Jane "Mae" West (1893-1980) was a buxom sex symbol during her film and stage career. (*341st Missile Wing Public Affairs Office*)

HISTORY FOR OUR PROGENY'S SAKE: Malmstrom Heritage Center director Curt Shannon (above left) talks to A1C Lakendra Peacock (center) and Airman Aaron Hollins (right), describing a museum exhibit about Malmstrom AFB's early years. The exhibit display contains a license plate from "Army Air Base, Great Falls, Mont." and a telephone directory for the "Alaskan Wing, Air Transport Command," recognizing two important missions at Malmstrom AFB during World War II and the post-war timeframe. The museum contains approximately 250 scale models (below), representing the aircraft and missile systems supported by the men and women of the airbase over the decades. The image below shows a diorama depicting the base during the Lend-Lease program. (*341st Missile Wing Public Affairs Office*)

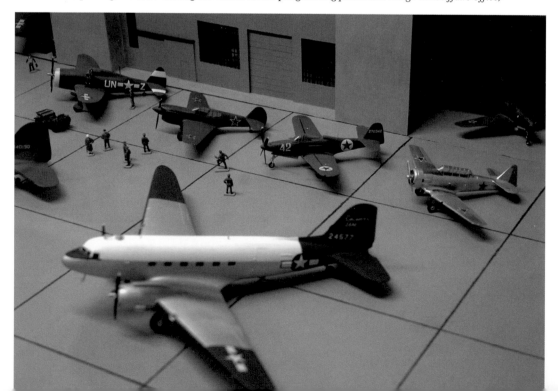

DEADLIEST ALUMINIUM CAN IN THE WORLD: An example of the Minuteman III's NS-20 guidance system (above) sits inside the Malmstrom Museum. Developed with 1960s-era technology, the NS-20 "guidance can" performed ground and in-flight functions for the weapon system, to include responding to commands received from the ground system, and constantly monitoring and reporting on the health of the missile to the missile combat crew. Since the Minuteman consists of multiple stages, the D-37D flight computer inside the NS-20 tracks when the booster is nearly out of fuel, signaling separation of the spent stage and ignition of the next one. Curt Shannon (below) describes the inner workings of the NS-20 to museum visitors. The NS-50 guidance system replaced the NS-20 in the operational Minuteman force, with NS-50s having higher reliability rates, requiring less maintenance and lowering operational costs. Malmstrom's maintainers installed the first NS-50 in the Minuteman force at India-09 (I-09) on August 3, 1999. Installation of the final NS-50 took place at Charlie-10 (C-10) on December 4, 2007. (*341st Missile Wing Public Affairs Office*)

DROPPING A BOMB IN A PICKLE BARREL: Army Air Forces bombardiers used the Norden bombsight (above) during World War II. The bombsight calculated precise timing for automatic bomb release over a specified target via the plane's autopilot. The bombsight was a critical wartime instrument. Prior to flights, bombardiers checked out the bombsight from the bombsight shop vault and transported it to the aircraft inside a sealed bag; after the mission, bombardiers would remove the bombsight and return it to the vault. Below, 341st Missile Wing vice commander Col. Robert Stanley (standing, far left) welcomes Jack Gamble, a World War II aerial gunner, and his wife and son, Ginny and Jim, to the Malmstrom Museum. Standing behind them are Bill Selling (second to right) and his brother, Mike Hanlen (far right). Selling and Hanlen donated the Norden Bombsight to the museum in memory of their father, a former trainee at Great Falls Army Air Base. (*341st Missile Wing Public Affairs Office*)

MISSION HIGHLIGHTS AT THE MUSEUM: Rob Turnbow describes historic vignettes about the base's training mission during the 1948 Berlin Airlift. Turnbow, a retired military member, spent his remaining active duty years at Malmstrom. Recognizing the helicopter mission as critical support for the missile complex, the museum added a display in 2017. Lt.-Col. Joshua Hampton, 40th Helicopter Squadron commander (left), Col. Ron Allen, 341st Missile Wing commander (center left), and Museum Director Rob Turnbow (center right), welcome retired Brig.-Gen. Dale Stovall (far right) during the dedication event on April 28, 2017. Brig.-Gen Stovall was a helicopter pilot during the Vietnam War, flying with the 40th Aerospace Rescue and Recovery Squadron. (*341st Missile Wing Public Affairs Office*)

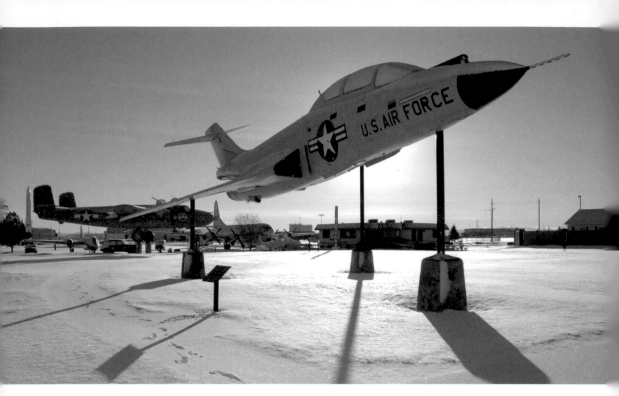

COLD WAR WARRIORS AT REST: A F-101 Voodoo (s/n 59-0419) (top) and KC-97G Stratofreighter (s/n 53-0360) sit outside the Malmstrom Air and Space Museum. The two static displays inform newer generations of Airmen about the perilous missions undertaken from Malmstrom AFB. Montana's contribution to national defense during the Cold War years stretched from under the ground—through Big Sky Country—and into outer space. (*341st Missile Wing Public Affairs Office*)

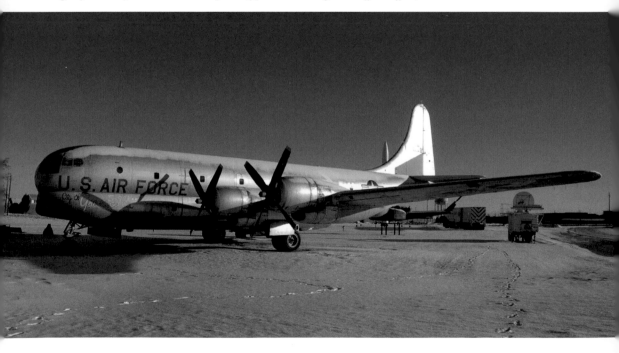

ABOUT THE MALMSTROM AIR AND SPACE MUSEUM

The Malmstrom Air and Space Museum contains artwork, artifacts, and displays about the base's history throughout the decades. Interior displays include one of the largest military model aircraft displays in the northwest, a World War II-era barracks room, flight suit and survival equipment displays, and many items from the Minuteman weapon system. Exterior displays around the museum include: F-101B/F Voodoo; B-25J Mitchell; EB-57 B/E Canberra; F-84F Thunderstreak; UH IF Iroquois; T 33 Shooting Star; KC-97G Stratotanker; and LGM-30G Minuteman III ICBM.

The museum is free and open to the public.

CONTACTING THE MUSEUM

Phone: 406-731-2705
E-mail: museum@us.af.mil
Hours: Monday–Friday: 10 a.m. to 4 p.m.
Closed on Federal holidays

MAILING ADDRESS

Malmstrom AFB Museu
341 Missile Wing/MU
21 77th St. North, Suite 144
Malmstrom AFB, MT 59402-7538

BIBLIOGRAPHY

341st Missile Wing History Office, "History of the 341st Missile Wing," Great Falls, MT: 341MW/HO (2014), minutemanmissile.com/documents/341stMissileWingHistoryPamphlet.pdf

Air Force Global Strike Command, *Final Environmental Assessment: Minuteman III and Peacekeeper Silo Elimination*, Barksdale AFB, LA: Air Force Global Strike Command A7A (2013), apps.dtic.mil/dtic/tr/fulltext/u2/a584865.pdf

Air Force Magazine, "Namesakes: Einar Malmstrom," airforcemag.com/article/namesakes-einar-malmstrom/ (October 1, 2019).

Fields, D., *Minuteman Missile: A Tribute to the ICBM Program*, minutemanmissile.com.

"Former Malmstrom Airman reunited with Olympic Arena toolbox" (July 24, 2014), malmstrom.af.mil/News/Features/Display/Article/825564/

GTE Sylvania, *WS-133B Minuteman Missile Weapon System: Ground Electronics System Description* (Needham Heights, MA: Electronic Systems Group/Communication Systems Division, 1975).

Maurer, M. (ed.), *Combat Squadrons of the Air Force, World War II* (Washington, DC: Office of Air Force History, 1982), media.defense.gov/2010/Dec/02/2001329899/-1/-1/0/AFD-101202-002.pdf.

Mills, D. W., *Cold War in a Cold Land: Fighting Communism on the Northern Plains* (Norman, OK: University of Oklahoma Press, 2015).

National Park Service, *Historic American Engineering Record: Malmstrom Air Force Base: 564th Missile Squadron (Minuteman III Missile Facilities)* (Denver, CO: Intermountain Support Office (Denver)), lcweb2.loc.gov/master/pnp/habshaer/mt/mt0400/mt0487/data/mt0487data.pdf.

War Department, *1944 Missing Air Crew Report 42-25513* (National Archives), fold3.com/image/28633388.

INDEX

ABOUT THE AUTHOR

JOSEPH T. PAGE II ("Joe") is a space historian and former Air Force space and missile officer. The space and history "bug" bit him early in life while growing up at White Sands Missile Range, New Mexico, the "Birthplace of America's Missile and Space Activity." After spending a decade in uniform, Page and his family finally settled in Albuquerque, New Mexico. He holds a Bachelor of Arts degree in history from the University of New Mexico. This is his first Fonthill Media title.